IMAGES
of America

HOLBROOK AND THE PETRIFIED FOREST

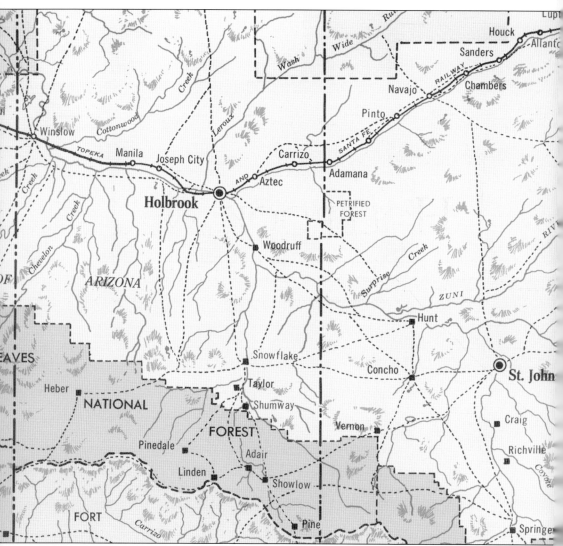

This 1912 map shows the Atchison, Topeka, and Santa Fe Railroad passing through Holbrook following the Rio Puerco. The Little Colorado River flows from St. Johns to Holbrook and then Winslow. Roads (dotted lines) connect Holbrook with other northeastern Arizona towns. The Petrified Forest, shown here as accessible only by road from Holbrook, was also an important railroad stop at Adamana.

ON THE COVER: Sheep provided two cash "crops," the sale of wool in the spring and lambs in the fall. Here freighters bring wool to Holbrook for shipment. The bags, 6 feet long and 3 feet in diameter, weighed about 200 pounds. A scale (center) is ready to weigh the bags. The market for wool was good until after World War I, when the U.S. Army ceased using wool uniforms. (Navajo County Historical Society.)

Catherine H. Ellis

Copyright © 2007 by Catherine H. Ellis
ISBN 978-0-7385-4885-2

Published by Arcadia Publishing
Charleston SC, Chicago IL, Portsmouth NH, San Francisco CA

Printed in the United States of America

Library of Congress Catalog Card Number: 2006939693

For all general information contact Arcadia Publishing at:
Telephone 843-853-2070
Fax 843-853-0044
E-mail sales@arcadiapublishing.com
For customer service and orders:
Toll-Free 1-888-313-2665

Visit us on the Internet at www.arcadiapublishing.com

*To Lloyd C. Henning, Garnette Franklin, and Harold C. Wayte Jr.,
who each spent their spare moments collecting and preserving Holbrook's
photographs and stories.*

Contents

Acknowledgments		6
Introduction		7
1.	Early Days	9
2.	Navajos, Apaches, and Hopis	23
3.	The Railroad and the Hashknife	39
4.	A Civilized County Seat	55
5.	Route 66 and the Petrified Forest	83
6.	Yesterday and Today	103
Additional Reading		127

ACKNOWLEDGMENTS

Before submitting the proposal for this book, I visited the Navajo County Historical Society in June 2006 and informally inventoried their photographs. Were there enough photographs for a book on Holbrook? Yes, and what memories were stirred! There were so many images of people I loved: Melvin Shelley, Ben Rencher, Launa Gardner, and even a photograph of my grandfather. Although 200 photographs seem like a lot for a small town, it is not nearly enough to represent everyone important to Holbrook's 125 years of history.

All photographs, unless otherwise noted, are from the Navajo County Historical Society (NCHS); Zelda Gray and Mary Barker were most helpful in providing access to this collection. The woodcuts are from Dover's *The American West in the Nineteenth Century*; early engravings were based on sketches but later were made from photographs. Two photographs are from the University of California Museum of Paleontology, www.ucmp.berkeley.edu. All photographs labeled Cline Library are from the Northern Arizona University, Cline Library, Special Collections and Archives. Other photographs are from the Arizona Historical Foundation at Arizona State University (AHF), Petrified Forest National Park (PEFO), Arizona Historical Society (AHS), National Archives, and Library of Congress. The quotes from Allen Hensley, Clifton Lewis, Edna Dobell, and Dick Mester are from *Route 66: The Highway and Its People*.

Many people have helped. Harold Wayte's thesis and Lyle Johnston's *Centennial Memories* were invaluable. Matthew Barger, Scott Benson, Paul DoBell, Bill and Betty Ferguson, JoLynn Fox, Sarah Crosby Gray, Leland Hanchett, Renee Hughes, Glen and Brenda Johnson, Ron Nichols, Dwight and Marie LaMar, Louise Levine, Arvin Palmer, David Shayt of the Smithsonian, Arthur Standiford Jr., Esther Stant, Gail Taylor, Scott Williams, and Gerald and Beverly Wischmann shared information and photographs. I am grateful to family members who helped with proofing, photographs, and expertise.

Finally, thanks to Dr. Jack August and Jared Jackson at the Arizona Historical Foundation and Christine Talbot at Arcadia Publishing, who supported this project in every way.

INTRODUCTION

"The Santa Fe [Railway] is doing a land office business now," wrote Pearl Hunt from Holbrook in February 1944. "They haul so much war material. Every day we see landing barges, Jeeps, trucks, tanks, etc. go by and even bombs once in a while, besides all that we can't see in box cars and tank cars by the dozens." A year earlier, she wrote to her son Max in the navy, "Trains and buses are loaded to the limit. Sometimes I wonder where they are all going. . . . Ledfors of the Rees Cafe say they served as many as 1100 a day. That's big business for a little place like that." World War II increased the bus and railroad traffic along Route 66 and the Santa Fe Railroad, but from its beginning, Holbrook was the hub for commerce north, south, east, and west.

In the 1870s, settlements began springing up along the banks of the Little Colorado River in northeastern Arizona. The earliest settlers were Hispanics from New Mexico, but Mormons also came from Utah. The Boston Party arrived in 1876 with hopes high from reading Lt. Amiel Whipple's glowing report: "With two hundred mules, besides beef cattle and sheep, we were able to camp where we pleased without fear for the want of grass. Nature has furnished grass, sufficient water and a climate most favorable." Instead the Boston natives found a high-elevation desert with grass dead and streambeds dry. Their captain wrote, "The valley of the Little Colorado we found to be much below our expectations as an agricultural country, the best part having been taken by the Mormons." The wagon train continued traveling west.

Early Spanish explorers occasionally traveled both north and south of present-day Holbrook, but their first attempts to colonize led to the Pueblo uprising of 1680. With only 9 inches of rain per year, with torrential summer rains producing floods, and with fierce spring winds providing sandstorms sans rain, this area was only sparsely used by Native Americans.

The first settlement began at a river ford called Horsehead Crossing a few miles east of present-day Holbrook. When the railroad arrived in September 1881, the community was relocated. It quickly became a center for commerce. In 1941, John Addison Hunt of Snowflake said, "Holbrook at that time was the center for all of that part of the country. When a person said they were 'going to town' they meant they were going to Holbrook." Cattle, sheep, and wool were shipped via the railroad, and commercial goods of all varieties were brought in by the same means. Supplies to Fort Apache, 100 miles south, came through Holbrook, and "about every two years," Bill Cross remembered, "the troops would be shifted as Fort Apache was an ideal spot for soldiers to recuperate."

With the railroad came the Aztec Land and Cattle Company, better known as the Hashknife from their distinctive brand (page 125). Headquartered in Joseph City and Holbrook, cattle were trailed from Texas or shipped to Holbrook and Winslow via the railroad. With the cattle came cowboys from Texas and New Mexico—some for adventure, others to escape warrants. Little did anyone realize the havoc cattle would wreak. "The famous Hash Knife Cattle Company shipped in and unloaded sixty thousand cattle in the Holbrook district," wrote Bill Cross, "with the results [that], in the next two years, [the cattle] not only ate all of the grass but tramped the roots until there was no grass left." Periodic drought was the norm, and summer thunderstorms brought

erosion once the grass was gone. Tumbleweed (Russian thistle) and tamarisk were introduced, changing the landscape.

A disastrous fire in 1888 destroyed nearly all of Holbrook's business district, but resourceful merchants immediately rebuilt. Liquor was readily available and gambling tables were always set up. Saloons with such colorful names as the Bucket of Blood made Holbrook a tough cow town. Early interesting characters included Commodore Perry Owens, the longhaired sheriff whose shooting of the Blevins gang sparked controversy; W. R. McNeil, a cowboy outlaw and poet; and Frank Wattron, whose invitation to a hanging brought censure from the president of the United States. Then in 1895, a new county was created—Navajo County, Arizona Territory—and Holbrook became the county seat. Mormon settlers in the nearby towns of St. Joseph, Woodruff, and Snowflake produced much of the green corn and squash, tomatoes and onions, cantaloupe and watermelon, and milk and butter for Holbrook.

The railroad and the highway later known as Route 66 brought tourists to the Petrified Forest. Some visitors were famous; John Muir, the great conservationist, spent much of 1905–1906 at Adamana while his daughter was recuperating from pneumonia. Geologists and paleontologists soon recognized Holbrook and the Petrified Forest as an important area for late Triassic fossils. Prof. Charles L. Camp from Berkeley spent many seasons excavating around Holbrook, and in 1936, Dr. Barnum Brown from the American Museum of Natural History in New York City uncovered in the Painted Desert the largest phytosaur skull to that date.

During World War II, Holbrook became the point of departure for servicemen from Navajo and Apache Counties. Those who stayed behind bought war bonds, grew victory gardens, and wrote letters by the thousands to buoy up Holbrook citizens far away. Native Americans (Navajo, Hopi, and Apache) also made significant contributions to the war, and Navajo Code Talkers have finally been given the accolades they deserve for their significant contribution in the Pacific.

Today other communities in Navajo County have outdistanced Holbrook's population. However, Holbrook is still the county seat and continues to host tourists visiting the Petrified Forest and Painted Desert.

One

Early Days

"At a bend in the road," wrote Martha Summerhayes, wife of a lieutenant recently stationed at Fort Apache, "the Mexican guide galloped up near the ambulance, and pointing off to the westward with a graceful gesture, said: 'Colorado Chiquito! Colorado Chiquito!' And, sure enough, there in the afternoon sun lay the narrow winding river." Thus in 1875, she described the Little Colorado River a few miles west of the ford known as Horsehead Crossing and later Holbrook. Juan Padilla built the first house at Horsehead Crossing, and Berado Freyde operated a saloon and store where no one left without food, even if they could not pay.

With settlement came a railroad station, and with the Aztec Land and Cattle Company came cattle by the thousands from Texas. Holbrook became a tough little cow town with shoot-outs rivaling those in Tombstone. Fort Apache used the railroad to rotate troops. "The pay escort, 30 soldiers and officers," wrote resident Bill Cross, "would come to Holbrook every month to receive the money to pay the soldiers and civilians. During their stay in Holbrook, business picked up in all lines, especially the saloons, as liquor was not allowed on an Indian reservation."

One outlaw, W. R. (Red) McNeil, robbed trains and stores—and wrote poetry. He held up Holbrook store owners Adolf and Ben Schuster in 1888, and after eluding Sheriff Commodore Perry Owens, left this poem on a tree:

I am king of the outlaws. / I am perfection at robbing a store.
I have a stake left me by Wells Fargo / And before long, I will have more.
 They are my kind friends, the Schusters, / For whom I carry so much lead.
 In the future to kill this young rooster / They will have to aim at his head.
Commodore Owens says he would like to kill me/ To me that sounds like chaff.
'Tis strange he would thus try to kill me/ The red headed son-of-a-gun.
 He handles the six shooter mighty neat / And kills a jack-rabbit every pop.
 But should he and I happen to meet / There will be a regular old Arkansas hop.

Holbrook had its share of colorful residents and visitors.

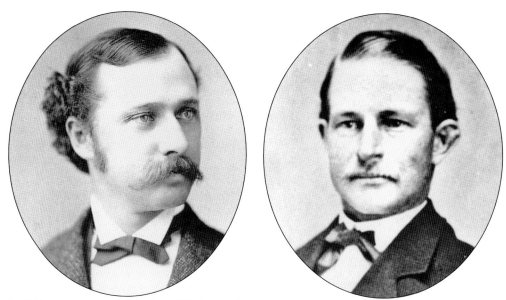

In 1882, railroad contractor John W. Young (left) named a new station along the Little Colorado River Holbrook after chief engineer Henry Randolph Holbrook (right). Holbrook began his career with the Union Pacific in 1862, working in Colorado, Missouri, Arizona, and Mexico. A eulogy noted "his little, nameless, unremembered acts of kindness and of love," but in Arizona his legacy is a railroad town. (Above Church History Library; below NCHS.)

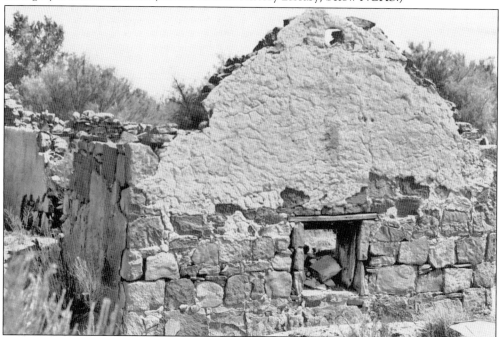

Juan Padilla arrived in the early 1870s and chose a ranch at the confluence of the Little Colorado and the Puerco. This may have been the location of Horsehead Crossing. The family raised as many as 500 or 600 milk goats and hauled freight. After the 1923 flood, the family moved five miles further east. The remaining foundation of the ranch house was photographed in 1981.

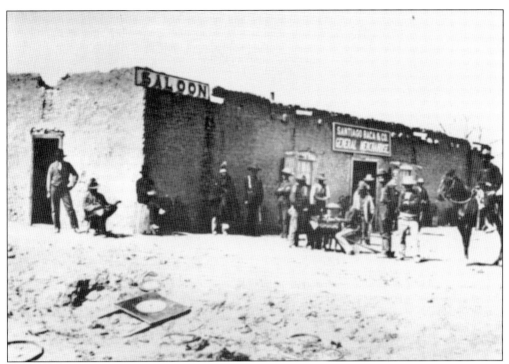

The earliest image of Holbrook is of Santiago Baca's store and saloon. The adobe/rock structure reflects Baca's New Mexico origins (and the few trees). In February 1883, Baca, Pedro Montano, F. W. Smith (a railroad employee), and H. H. Scorse filed the plat for the town. The next year, Civil War veteran Francis Zuck bought out Baca and Montano, then worked tirelessly to develop the community.

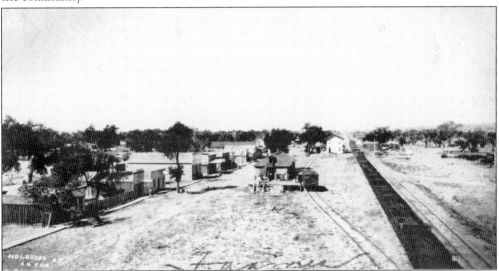

This is Holbrook in 1886, with the Atlantic and Pacific Railroad depot at center. Will C. Barnes arrived in 1883 and described Holbrook as "a wild and woolly town with a population of about two hundred and fifty persons. Three stores, a photograph gallery run by a Chinaman, a chophouse, and five saloons made up the business end of the hamlet." (Photograph by F. A. Ames; National Archives 106-FAA-88A.)

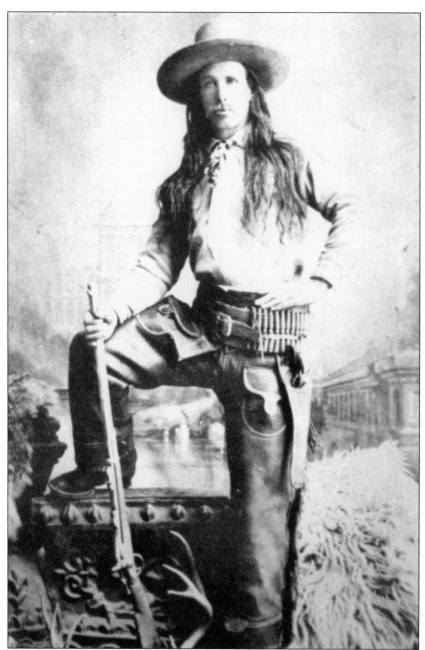

The most famous and most controversial shoot-out in Holbrook was on September 4, 1887, between Commodore Perry Owens and Andy Cooper of the Blevins gang. This flamboyant image of Owens has become famous. When Owens arrived in Holbrook, he was advised that Cooper was at a rented cottage, but did Owens know how many people were in the rented cottage? Besides the men (Cooper, John Blevins, and Mose Roberts), there were three women and six children. The sheriff first calmly cleaned his Winchester rifle. Then he approached the door alone because he did not "want anyone hurt in this matter" and advised Cooper of the arrest warrants.

Sheriff Owens fired the first shot when Andy Cooper raised his gun. Owens shot at each movement from the house through door, front window, and wall: a total of five shots. When the smoke cleared, three men were dead or dying and one was wounded. Owens had not a scratch, although his horse tied up outside had been hit. The gunfight lasted less than five minutes. The newspaper reported that "several citizens went to the house, where a horrible sight met their gaze. Dead and wounded in every room, and blood over the floor, doors and walls." Ma Blevins always believed the incident was unprovoked; most Holbrook citizens supported the sheriff. John Blevins, although wounded, recovered and lived in Holbrook for many years. Two of his children, Delilah and Andrew, are shown here about 1915.

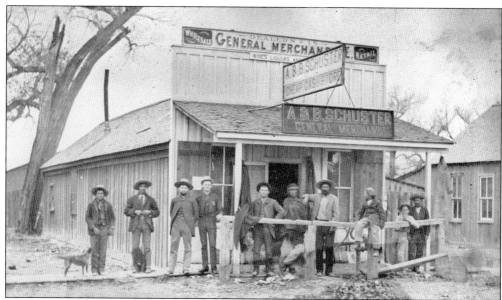

Adolf and Ben Schuster, twins born in Germany, purchased this frame building in 1884 and opened A&B Schuster Company. Most of Holbrook's business district, however, was destroyed on June 23, 1888. Started by spontaneous combustion in a warehouse filled with wool, the fire left "Every Business House and Many Residences Destroyed," according to a headline in the *St. Johns Herald*. The paper also reported that Holbrook was "a smoking mass of ruins, a sorrowful sight to contemplate."

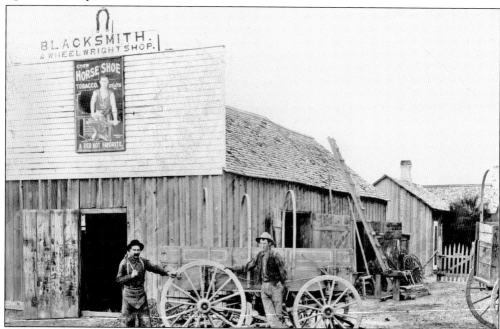

South of the railroad tracks, a new business district sprang up including livery stables, Loui Sam Kee's Restaurant, Cottage Saloon, Wattron's Holbrook Drug, Pioneer Saloon, and Scorse's Mercantile. This is William Armbuster's blacksmith shop. Armbuster immigrated to America from Germany in 1875 and originally came to Arizona with the U.S. Army. (Maryann Coulter.)

THE HOLBROOK HOTEL
R. L. NEWMAN, Proprietor

**PLEASANT PARLOR AND LOBBY
STONE FIRE-PROOF BUILDING
Barber Shop, Ladies' and Gents' Bath in Connection**

One of the first buildings to burn was F. M. Zuck's home, originally called Holbrook House, where rooms were rented and where the stage to Fort Apache departed. Immediately after the fire, Zuck erected this two-story rock building and named it Hotel Holbrook, illustrated here in the 1913 *Arizona Good Roads Association Illustrated Road Maps and Tour Book*. (William E. Ferguson.)

In 1885, Louise Cross boarded the train in Illinois and traveled to Holbrook with her four children. The children (Bill and three daughters) stayed in Woodruff, but Louise returned to Holbrook to work for the Zucks. Auntie Cross had a sunny disposition and made friends with everyone. Roberta Flake Clayton said, "Most of the cowboys in the country would tell you that she taught them how to dance." (Gerol Smith.)

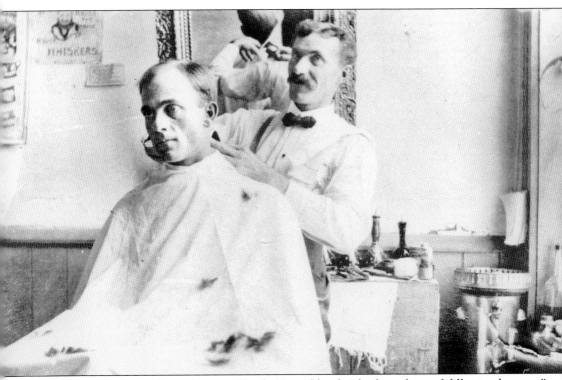

Bill Cross is shown here shaving Claude Youngblood, "the best dance fiddler in the area," according to Kenner Kartchner. Cross returned to Holbrook in 1902 after an absence of eight years. He later recalled this time, saying, "I walked in and renewed acquaintances and asked for the barber. Joe Woods, the boss, said, 'Barber hell! We had a barber, and about three weeks ago there was a S of a B killed him right out in front.' . . . I said I was needing a shave pretty badly, and our baggage didn't come on our train, and my barber tools were in my trunk. Joe said, 'Hell. Are you a barber?' and I said I was. He said, 'Come on back in the barber shop as I have some of the dead barber's tools.' We went back and he dug up a couple of razors which were awfully dull, but I honed one and shaved myself. When I had finished, Joe said, 'Say, will you shave me?' I said, 'Get in the chair.' Well, I shaved Joe, and his bar tender Jose Nochie, and I never quit the barber business for 32 years." (Rob Cross.)

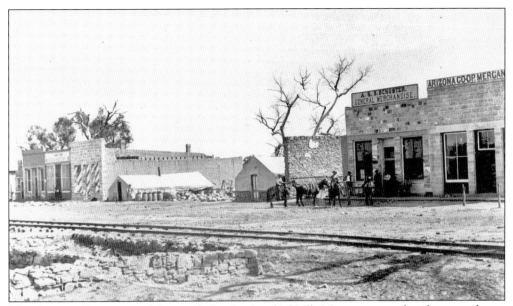

The Arizona Cooperative Mercantile Institution (ACMI), Mormon owned and operated, was originally located at Horsehead Crossing. When the railroad bypassed this spot in 1882, the store was literally moved to Woodruff. A new building (above) was built after the fire of 1888. It sold everything: feed for cows and horses, bales of hay, and sacks of grain and rolled oats. (National Archives, 106-FAA-86.)

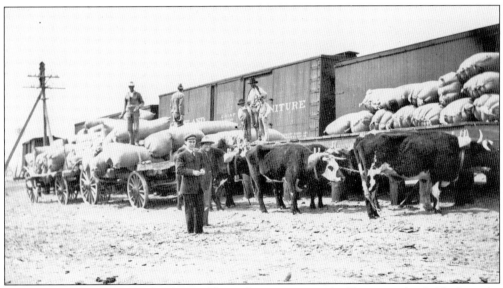

One Mormon business was freighting. Shown here is a six-ox double wagon (probably from the Scorse ranch), but most freighters used six horses. The round trip to Fort Apache took 8 to 10 days. December 1890, however, was extremely wet, so William J. Flake used a 20-horse team, and the trip lasted 20 days. With this extra effort, the ACMI was able to get Christmas supplies delivered. (Maryann Coulter.)

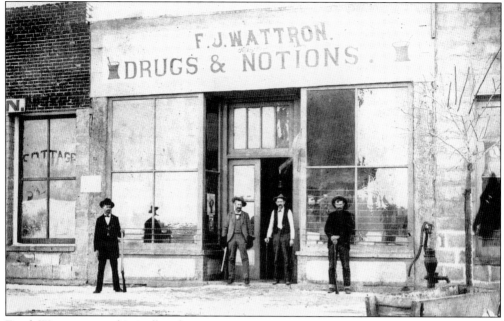

Frank Wattron arrived in Holbrook in 1883. He opened a drugstore but was also appointed deputy sheriff. Wattron was known as "a potent factor in preserving law and order" and "a bad man to cross," according to Harold Wayte. Next door is the Cottage Saloon, locally known as the Bucket of Blood because of a disputed poker game where blood from two men looked like it had been spilled from a pail. (Maryann Coulter.)

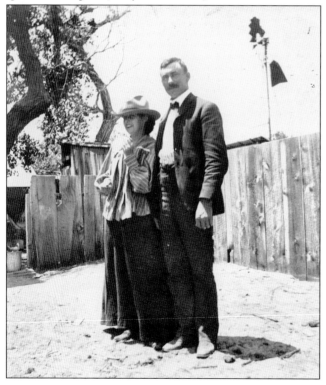

Local schoolteacher Estelle Herstein and Frank Wattron were married January 27, 1887. She wrote, "Look at my ten cent smile," and "Our gallent [sic] young sheriff." Harold Wayte wrote that Wattron "smoked long black cigars, carried a sawed-off double-barreled shotgun under his long frock coat . . . and swore 'artistic, strange and terrible oaths.'" Wattron was also addicted to laudanum, a tincture of opium.

Holbrook, Arizona, ~~Jan 1st 1900~~ Dec 1st 1899

Mr. R. B. Berryhill

You are hereby cordially invited to attend the hanging of one

George Smiley, Murderer.

His soul will be swung into eternity on ~~January~~ Dec 8, ~~1900~~ 1899, at 2 o'clock, p. m., sharp.

Latest improved methods in the art of scientific strangulation will be employed and everything possible will be done to make the proceedings cheerful and the execution a success.

F. J. WATTRON,
Sheriff of Navajo County.

Sheriff Wattron's macabre sense of humor comes through in this invitation to the hanging of George Smiley, Navajo County's first legal execution. Wattron's ire may have been raised by the nature of the crime (Smiley shot a man in the back in Winslow over one day's wages not paid) or by the lack of remorse. When the Albuquerque newspaper published an article about the invitation (above), newspapers as far away as Washington, D.C., and London picked up the story. Pres. William McKinley sent a message of condemnation to Gov. Nathan Oakes Murphy of Arizona Territory, who forwarded the same to Wattron with a 30-day stay of execution. Wattron's response was to issue a second invitation bordered in black (bottom), but it was sent only one day before the hanging. (Beulah Stratton.)

Revised Statutes of Arizona, Penal Code, Title X., Section 1849, Page 807, makes it obligatory on Sheriff to issue invitations to executions, form (unfortunately) not prescribed.

Holbrook, Arizona, Jan. 5th, 1900.

Mr. R. B. Berryhill

With feelings of profound sorrow and regret, I hereby invite you to attend and witness the private, decent and humane execution of a human being; name, George Smiley; crime, murder.

The said George Smiley will be executed on January 8, 1900, at 2 o'clock p. m.

You are expected to deport yourself in a respectful manner, and any "flippant" or "unseemly" language or conduct on your part will not be allowed. Conduct, on anyone's part, bordering on ribaldry and tending to mar the solemnity of the occasion will not be tolerated.

F. J. WATTRON,
Sheriff of Navajo County.

I would suggest that a committee, consisting of Governor Murphy, Editors Dunbar, Randolph and Hull, wait on our next legislature and have a form of invitation to executions embodied in our laws.

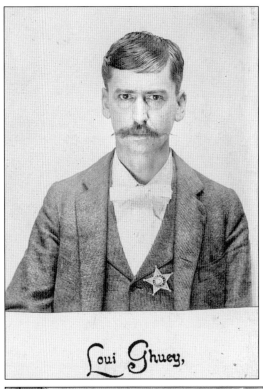

This image of Frank Wattron (note his gold star with a diamond in the center) bears the imprint of Loui Ghuey, who took many early Holbrook photographs. Ghuey lived in Winslow in 1900 and was listed as a Chinese merchant. Other Chinese in Holbrook cooked, did laundry, and ran restaurants. Most came to America from 1870 to 1890 without their families.

This unidentified Southwestern town could have been Holbrook. Said one resident, "The Hashknife cowboys would gallop through Holbrook with blazing guns, yelling: 'Hide out, kids, the cowboys are in town,' shoot out the lights at dances, and otherwise justify wildest western traditions." The newspaper in 1886 suggested, "Have a good old fashioned time, if you want to boys, but lay aside your pistols." (*Frank Leslie's Illustrated Newspaper*, January 14, 1882.)

In 1885, Juan and Damasia Baca arrived from Springerville. Their family of attractive daughters brightened the social scene. Josephine married Ben Schuster, Sarah Louise married Dr. Sydney Craig (and after his death, John Perkins), and Mollie married sheep rancher John Nelson. Kenner Kartchner wrote, "No one willing to do his job well ever worked for nicer people than John and Mollie Baca Nelson." Hanchett labeled this photograph "the Bacas out for a swim." (Leland Hanchett Jr.)

Early visitors to the Petrified Forest included these from Snowflake. This may be the 1897 visit May Hunt Larson mentioned when writing about Professor Devol of the University of Arizona, who was advocating sugar beet cultivation. John Hunt took Devol to St. Johns, Concho, and the Petrified Forest. They "enjoyed a very pleasant journey and brought home some nice specimens of the forest," she wrote. (Albert Levine.)

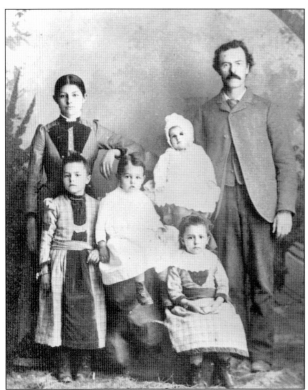

Henry H. Scorse was born in England in 1851 and immigrated to America in 1869. He traveled throughout much of the West (in Montana in 1880) before settling in Holbrook. In 1881, he married Julianita Garcia, who shortened her name to Julia and changed it to the English pronunciation. This image includes, from left to right, Julia, children Ellen, Henry Jr., Rose (baby), Julia, and Henry. (Maryann Coulter.)

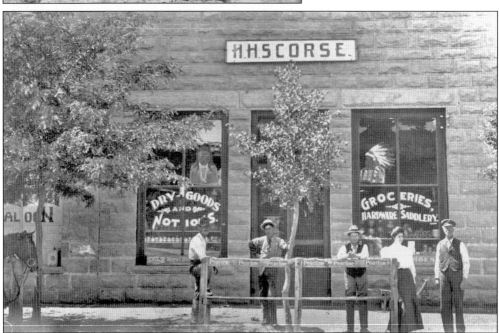

H. H. Scorse, proprietor of the Pioneer Saloon at Horsehead Crossing, moved his business into one of Holbrook's first frame buildings. After the fire of 1888, he set up business in a tent and then rebuilt with stone. His dry goods, notions, groceries, and hardware store is shown here immediately adjacent to the saloon. (Maryann Coulter.)

Two

Navajos, Apaches, and Hopis

When Anglos arrived in northeastern Arizona, Native Americans were only lightly using the Little Colorado River. This area was a buffer between Apaches to the south, Navajos to the north, Hopis to the northwest, and Zunis to the east.

Anglo–Native American relations have always been complicated. Early settlers were afraid of both Navajos and Apaches. An unidentified descendant of Amelia Anderson Cross wrote that Cross "was in the front room of her home [in Holbrook about 1910, an] Indian stepped into the kitchen. She was frightened, but did not let him know it, and asked what he wanted. He said, 'Whisky.' She told him she did not have any, but he pointed to a bottle up on the cupboard that had cough syrup in it. He wanted that bottle and she had to get it down. When he smelled it, he said, 'No whisky,' and finally left."

It is difficult to provide balance in documenting Anglo–Native American relationships. Carlton Culmsee, in his 1973 book, *Utah's Black Hawk War*, included his original 1934 *Deseret News* articles and discussed the difference 40 years made in perspective. He wrote, "One of the most troubling questions . . . arose from the tone, perhaps prejudice, of my original articles. I had drawn heavily . . . upon letters and journal accounts written by [Anglo] veterans and had interviewed many witnesses of war incidents. Such material radiated pride in the bravery of whites and horror at atrocities by redmen. The attitude toward Indians has of course veered considerably. Many of us now feel much more contrition when we recall how white pioneers, military forces and the national government dealt with earlier Americans and their lands on the frontier." Culmsee noted that every generation's opinions, however, were "grounded on emotions that, for good reasons or poor, incontestably do or did exist." Therefore he simply added to the original material and said, "I hope only to attain something of a balance rather than a basic reconciliation of opposites or the substitution of one viewpoint for its opposite."

This attempts a balance for Holbrook.

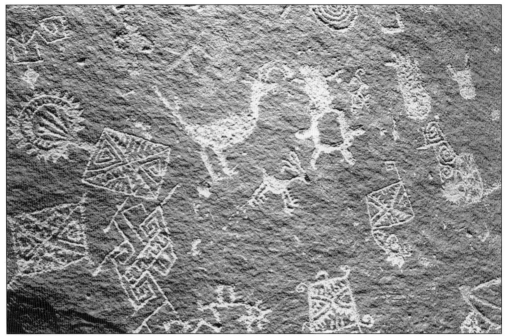

Pictographs can be found in areas where leached iron oxides form a patina on the rocks, making such artwork possible. This example, located about four miles west of Holbrook, was photographed in 1938. Additional rock art was found at Petroglyph Park in Holbrook behind the golf course, at Newspaper Rock in the Petrified Forest, and at Rock Art Canyon Ranch. (Photograph by Max Hunt.)

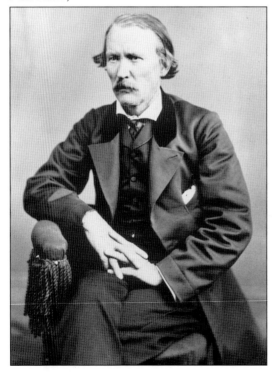

In 1863, Kit Carson was recruited to help the military subdue the Navajos (Diné, as they call themselves). As a base of operation, Carson established Camp Supply on the Little Colorado River at approximately Horsehead Crossing. Nothing remains of this camp, perhaps because it was entirely under canvas and only in existence for a short time. (Library of Congress.)

This image from Lt. George M. Wheeler's 1873 expedition reminds one of the Long Walk forced upon the Navajos in 1864 when relocated to Bosque Redondo in eastern New Mexico. As Navajo leader Barboncito stated before a negotiated return in 1868, "The bringing of us here has caused a great decrease of our numbers, many of us have died, also a great number of our animals." (Photograph by Timothy O'Sullivan; National Archives 77-WF-77.)

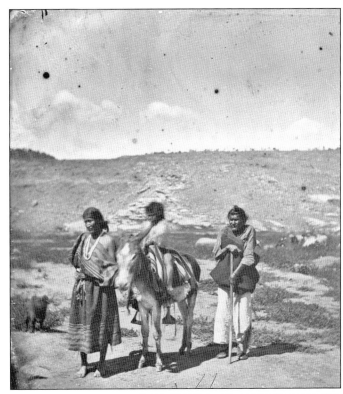

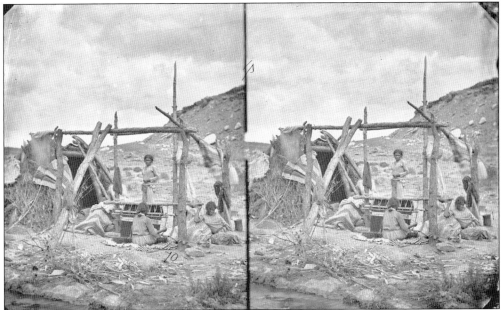

The soldiers, scientists, mule skinners, packers, and guides of Wheeler's party traveled and surveyed Arizona from Canyon de Chelly to Fort Apache. Timothy O'Sullivan made this stereo image illustrating the upright loom Navajos used then and now to create world-famous rugs. Stereophotography was popular in the Victorian age; a proper viewer gave an illusion of depth. (National Archives 77-WF-70.)

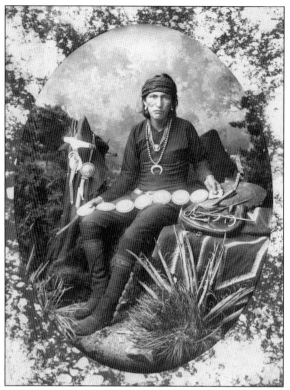

Harold Wayte described Holbrook as "the center of many difficulties between whites and Navajos over mutual cattle stealing and land and water rights." However, both groups benefited from trade. John Addison Hunt said, "There was always Navajo Indians that could talk more or less Spanish," so Spanish became the language of trade. Here a Navajo silversmith displays his work and tools around 1880. (Photograph by Will Soule; National Archives 75-BAE-2421B-6.)

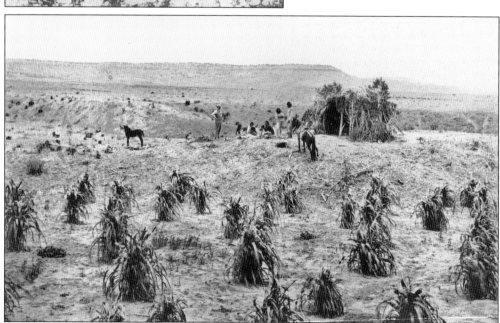

From 1887 to 1889, F. A. Ames traveled from Holbrook to the Grand Canyon taking photographs for the Bureau of American Ethnology. Ames took this image in 1889 and labeled it "Navahoe Indian 'Hogan' and corn field." Note that early hogans were not the octagonal, horizontal log structures seen today but were made of upright branches. Many were later "plastered" with mud. (National Archives 106-FAA-54.)

In the late 1800s, "the Navajos were very, very poor out on the reservation and they had lots of blankets," said John Addison Hunt. "They had no sale for their blankets, but it's the only way they had of making a living. They'd load horses down . . . and come over into our country . . . and trade the blankets for anything they could get to eat or use or wear." By 1900, a system of trading posts provided a market for Navajo rugs and jewelry. The backgrounds in these photographs of an unidentified baby and a toddler illustrate Navajo blankets in early Arizona homes. The toddler is Martha Turbeville, three-and-a-half-year-old niece of Esther Henning, in 1921. She was Miss Holbrook of 1938 and represented Arizona at the Texas Mardi Gras in February 1940. (Above Max Hunt; below NCHS.)

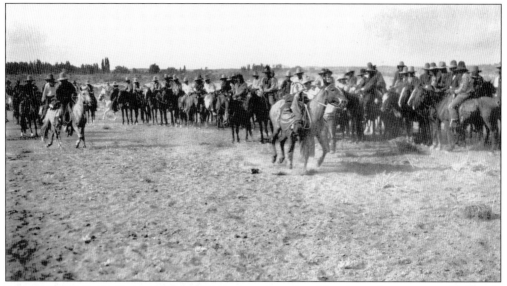

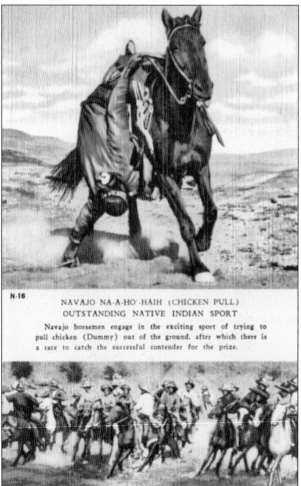

N-16 NAVAJO NA-A-HO'-HAIH (CHICKEN PULL)
OUTSTANDING NATIVE INDIAN SPORT
Navajo horsemen engage in the exciting sport of trying to pull chicken (Dummy) out of the ground, after which there is a race to catch the successful contender for the prize.

Navajo cowboys came to Holbrook and neighboring towns for rodeos. One event limited to Navajos was the "chicken pull" (above in 1927 and below on an undated postcard). A full-grown rooster was buried up to its neck in the ground, and then the contestants rode by at a slow gallop. The winner, pulling the head off the chicken, received the chicken and a cash prize. The event was later considered inhumane, discontinued, and a canvas bag was substituted for the chicken. With the substitution came an additional variation: the other cowboys chased the rider in an attempt to take away the "chicken." (Photograph by Philip Johnston; Cline Library NAU.PH.413.1.)

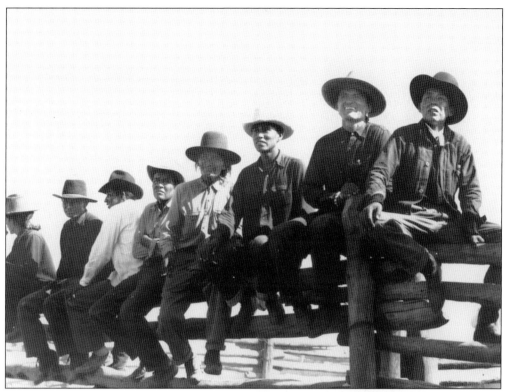

"One of the chief Navajos," wrote Max Hunt, "was named Billy 'A.' He was a fierce looking fellow. He wore his long hair folded several times and tied up in the traditional Navajo style with nearly a whole ball of string wrapped around it. We kids were afraid of him and the other Navajo cowboys. They wore ten gallon hats, Levis, and handmade moccasins with silver coins for buttons." Hunt photographed these cowboys at a rodeo in 1938.

Holbrook residents visited Navajo and Hopi lands, usually for commerce. Artifacts collected by Frank Wattron, H. H. Scorse, and Jack Guttery were displayed in stores in Holbrook, but none remain in the area. Instead, they are at the Field Museum in Chicago, the University of Arizona, the University of Pennsylvania, and the Smithsonian Institution. Here Allie Cross (Folger) is photographed with two Navajo children c. 1920.

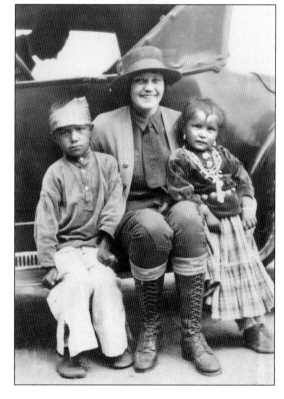

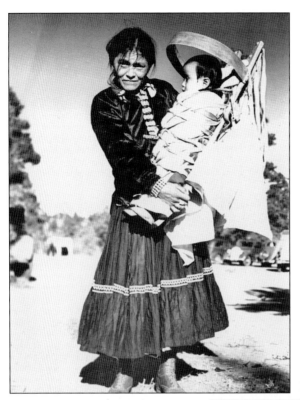

As late as the 1950s, Navajos were regularly seen in Holbrook in traditional dress. The women wore long, colorful, velveteen dresses with squash-blossom necklaces or turquoise jewelry. Babies were carried in traditional cradleboards, wooden platforms with leather straps to secure the baby (above, c. 1940). The photograph of the mother below (in a calico dress) is in Joseph City in 1938. Note the Works Progress Administration (WPA) sidewalks and the canvas water bag carried by the boy. When Navajos came to Holbrook to trade, they often left their horses and wagons at the fairgrounds. As they walked, many of the women had the deep limp (and considerable pain) characteristic of untreated congenital hip displacement. (Above AHF, DD-32; below photograph by Max Hunt)

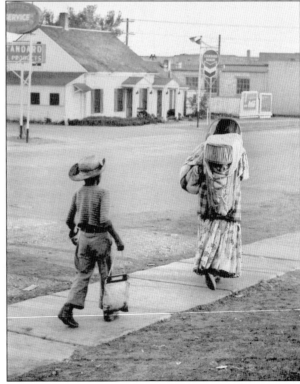

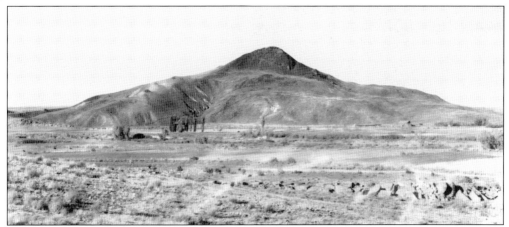

Woodruff Butte, a prominent landmark 10 miles southeast of Holbrook, rises 600 feet above the plain. This old volcanic cone was originally sacred to the Navajos, who climbed it to collect jimson weed. Unfortunately, ownership of the butte has passed into private hands, and the butte is currently being removed for cinders. (Photograph by Max Hunt.)

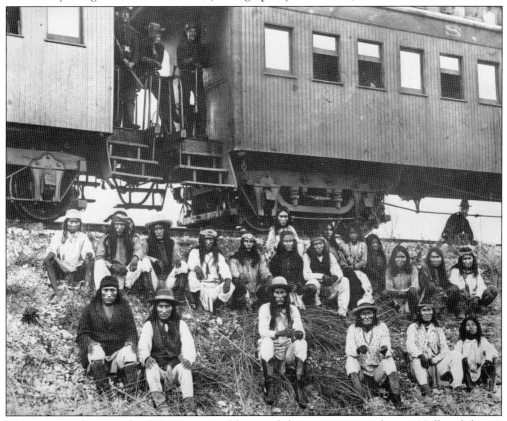

This famous photograph of Geronimo and his confederates was not taken at Holbrook but at a rest stop in Texas in 1886, after his final surrender. Geronimo was born in the late 1820s and named Goyankla; his wife and daughters were killed by Mexican troops in Chihuahua in the 1850s. Thereafter Geronimo spent decades killing Mexicans and White Eyes. (National Archives 111-SC-82320.)

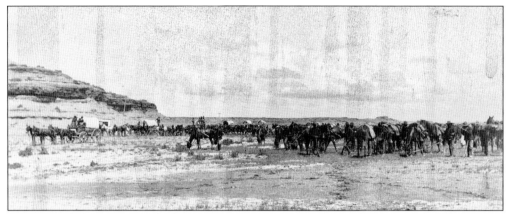

Although labeled "U.S. cavalry bringing in Geronimo's band to Holbrook from [Fort] Apache," these are Chiricahua Apaches, who had earlier been relocated to the White Mountains. They were brought to Holbrook for deportation at approximately the same time Geronimo was sent to Florida. Some had earlier served as scouts for the army; their deportation helped convince Geronimo to surrender.

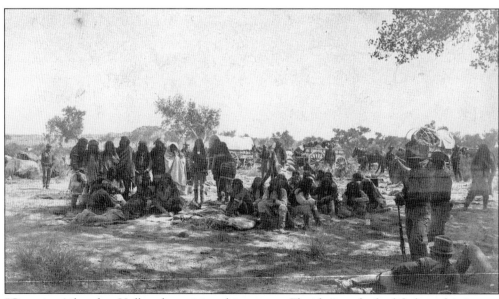

"Geronimo's band at Holbrook awaiting shipment to Florida," reads the label on this image. Holbrook residents feared the Apaches, although usually worrisome only when traveling south. Bill Cross told of an 1886 trip from Woodruff to Safford: "We had to be on a sharp lookout for Indians. Fortunately, we made the trip without encountering any blood thirsty warriors."

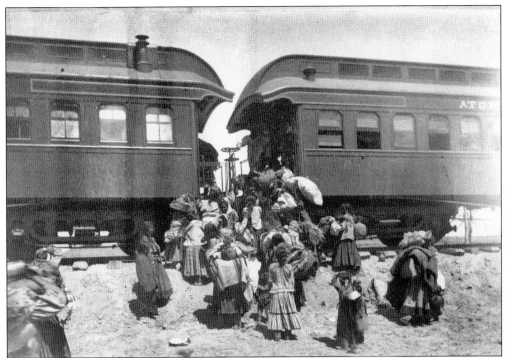

"'A good riddance.' Geronimo's family leaving for the 'Ponce de Leon,'" wrote the photographer, but by World War II, considerable pride was shown as newspaper articles told of Navajo County Native Americans in the military. In August 1942, a large quota of soldiers left Holbrook, and one headline read, "Six Apache Braves Ready for War Path," a quote from the Apache men themselves.

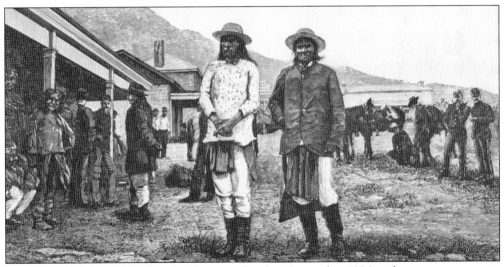

Geronimo (right) and Natchez finally surrendered in September 1886 and were put on a train to Florida. Emotions ran so high that government troops had to protect the Apaches from being lynched at Deming, New Mexico. In 1894, Geronimo was moved to Oklahoma, where he died 23 years after leaving Arizona. While in Oklahoma, he dictated his biography, flourished as a farmer, and attended Theodore Roosevelt's inaugural parade. (*Harper's Weekly*, October 2, 1886.)

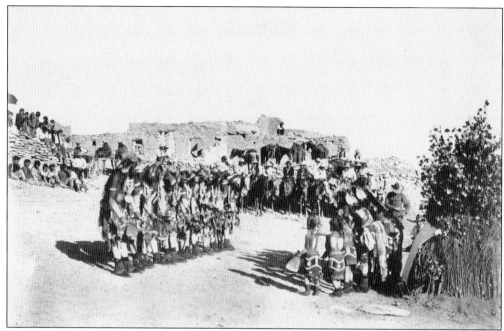

By 1895, tourists came to Arizona for the Hopi Snake Dance in August. Other Hopi ceremonies did not hold the same fascination. The dance has opened and closed many times—at times because it was outlawed by the government and at other times because it was considered sacred. At present, it has been reopened. Lololma of Hotevilla said, "If only one, two, or three spectators, with good hearts and good thoughts merge with our thoughts of prayer to accomplish our success, that is good." For the nine-day ceremony, Hopi men gather poisonous and non-poisonous snakes, then perform most of the ceremony inside the kiva. After the priests emerge and dance with the snakes, each snake is released to carry a request for rain to the gods. These photographs are probably from the village of Walpi; they were taken in 1915 when Theodore Roosevelt visited the Hopis. (AHF DD-107, DD-117.)

In 1879, at Walpi, John K. Hillers photographed these Hopi girls dressed in the traditional blanket-dress draped over the right shoulder. The "maiden whorls" in their hair and the cornmeal on their faces show that they are unmarried. Of her 1919 wedding day, Helen Skaquaptewa wrote, "After my hair was dry . . . they combed it up like a married woman, never to be worn in maiden style again." (National Anthropological Archives, Smithsonian Institution.)

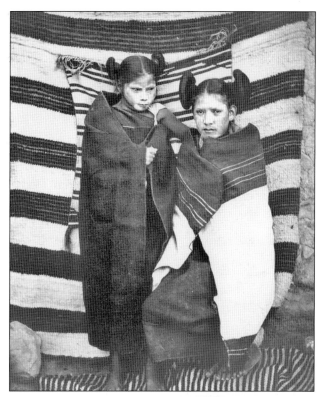

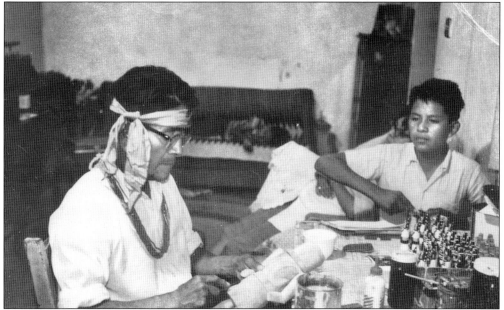

Emil Pooley, a Hopi resident of Joseph City from 1950 to 1964, carves a "tourist" kachina while his son, George, watches. Pooley was taken from his village as a child, brought to Holbrook, and put on the train for school in Albuquerque. (A brother was sent to Phoenix and a sister to Riverside, California.) It was three years before he was allowed to return. Pooley sold kachinas from Albuquerque to Phoenix. (Esther Stant.)

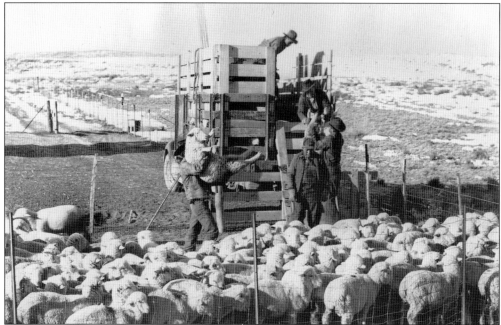

Federal officials became concerned about soil erosion on Navajo lands by 1928 and worked to limit sheep, horses, goats, and cattle. Sometimes livestock were forcibly removed and shot with little compensation. The much-despised livestock-reduction plan also affected Hopis, shown above loading sheep 18 miles southwest of Keams Canyon in January 1944. The men have already loaded the lower section of the truck and are now lifting sheep onto a second tier. The sheep were then taken to the Holbrook stockyards (below) for loading on railroad cars. Approximately 350 ewes, lambs, and goats equaled one carload. (Both photographs by Milton Snow; Cline Library HCPO.PH.2003.1.HM5.26 and 34.)

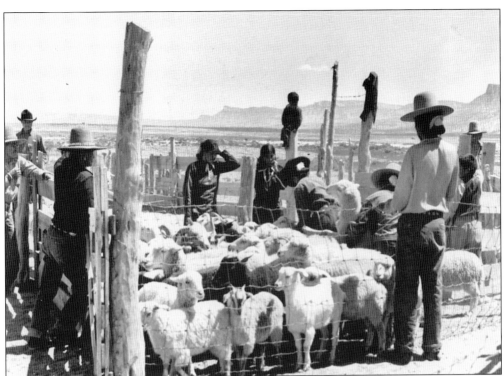

A more palatable government regulation was annual sheep dipping (shown here near Kayenta, June 13, 1941). Skin diseases, particularly scabies, and blowflies were controlled by sheep being made to swim through a trough of pesticides. Similar troughs have been used in Wales, Patagonia, and New Zealand. Wool and work are the most important ingredients of Navajo rugs. *Churro* sheep came from the Spanish in the late 16th century, and weaving techniques were adapted from the Pueblos. The sheep must be sheared, and then the wool is washed, carded, and spun. Commercial dyes are optional. A 3-foot-by-5-foot rug may take more than 200 hours to weave. (AHF DD-11, DD-12.)

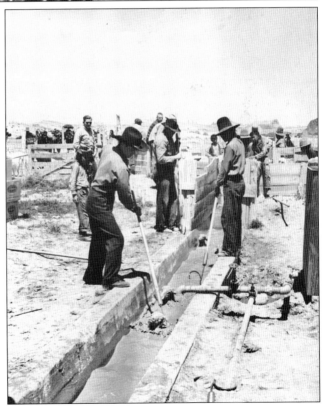

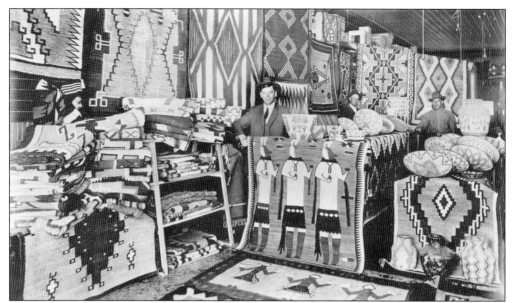

Fred Wetzler immigrated to America from Germany about 1890. An early merchant in Holbrook, he spent some time in San Francisco in 1910 but then returned to Holbrook. His collection of Navajo rugs (shown here on a postcard) was extensive and is similar to those of the famous trader Lorenzo Hubbell and collector Gilbert Maxwell.

In the 1950s, Holbrook participated in the federal program to educate Native American children off the reservation. Initial accommodations were temporary at the Arizona El Rancho Hotel. Regular dormitories were later constructed, but some early classes were held in churches. Garnette Franklin photographed these dormitory students at a Methodist Sunday school.

Three

THE RAILROAD AND THE HASHKNIFE

The Santa Fe railway was born through the hard work and vision of one man, Cyrus K. Holliday. Originally from Pennsylvania, Holliday traveled to Kansas in 1854, a young man full of ambition and high hopes. He joined other men in staking out the new town of Topeka and became one of its most important promoters. His dream was to connect Chicago with the Pacific coast, but not along the Mormon or Overland Trails to the north or the Butterfield Trail in southern Arizona. He planned the route that would run from Chicago to Santa Fe (through Topeka, of course) and then follow the 35th Parallel to California. His dream became known as the Atchison, Topeka, and Santa Fe Railroad.

Railroad construction required planning. Surveyors first plotted the general route and then engineers considered the exact grades and curves. Horse- and mule-drawn scrapers prepared the ground so the ties and rails could be laid; tracklayers could complete one to three miles of track each day. Bridges were built several miles ahead of the tracks. The most difficult one in northern Arizona was over Canyon Diablo, 65 miles west of Holbrook. The bridge, 560 feet long and 222 feet above the canyon floor, required six months to construct.

With the railway came large numbers of cattle from Texas. Drought around the Pecos River meant the Aztec Land and Cattle Company began looking for grass to fatten their cattle. Northern Arizona's ranges were ungrazed, and the Aztec-arranged purchase of the alternate sections the Atlantic and Pacific Railroad had been granted to encourage railway development. Cattle were shipped to Arizona in freight cars or were trailed (or a combination of the two), and the rail-versus-trail debate began. Sheep were also shipped in for Santiago Baca and other New Mexico Hispanics. When ready for market, both sheep and cattle were shipped to places such as Topeka, Denver, and Chicago.

Rail lines became Holbrook's link to the world.

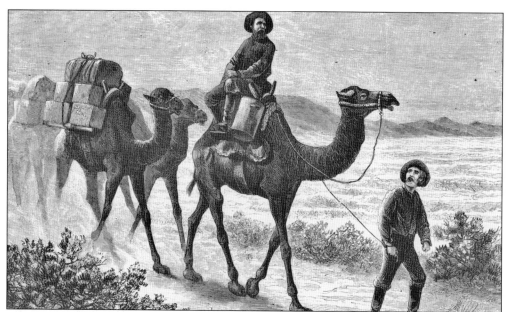

In 1857, Lt. Edward Beale led an expedition from Fort Defiance to California, unique because it included 25 camels (imported along with drivers). Beale was impressed with the camels' abilities in the desert, but cowboys detested them. Used again in 1858–1859, the camels were then turned loose. Stray camels were occasionally spotted into the 20th century. (*Harper's Weekly*, June 30, 1877.)

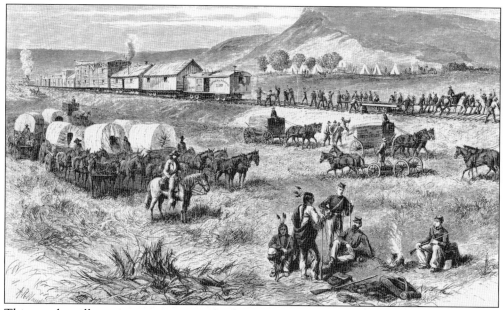

This woodcut illustrates most aspects of railway construction. Covered wagons are delivering supplies from nearby towns, and flatbed wagons are bringing ties. The construction train includes machine shops, kitchens, offices, water supplies, and sleeping accommodations (car with three tiers of windows). Workmen near the train are lowering a rail into position over the ties. In northern Arizona, local Native Americans even helped with construction. (*Harper's Weekly*, July 17, 1875.)

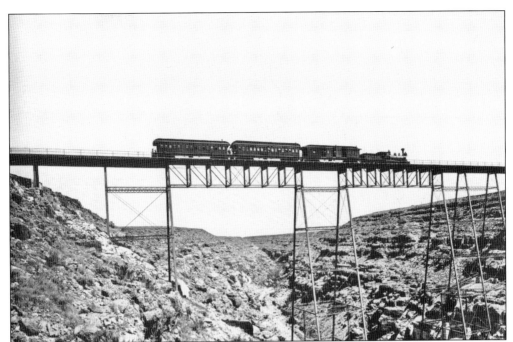

Photographs of the bridge at Canyon Diablo were always spectacular. Trains often stopped in the middle of the bridge to be photographed and to let passengers to see the view. Modern billboards have precedent here; signs advertising clothing stores and other businesses in Albuquerque were painted on the rock walls. (Photograph by John Hillers; National Archives 57-PS-109.)

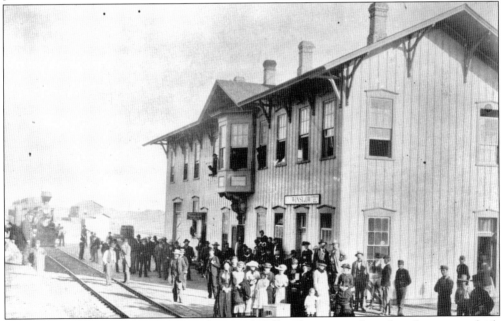

Winslow, 30 miles to the west, soon outdistanced Holbrook in size, and good stock pens were built for holding cattle. Railroad men chose to live in Winslow, a town that had a library and hospital. This two-story depot was photographed about 1890. Directly behind the women (center) is the band of the 22nd Infantry. (National Archives 111-SC-97979.)

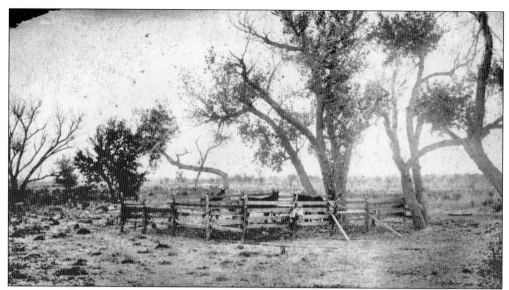

With drought in Texas, Hashknife cowboys brought 12,337 head of cattle into Arizona in 1885. The owners/foremen did not understand this was a land of periodic drought (note dead branches in the trees near an Aztec corral). These ranges can support four head per section, approximately the number in 1886, but more cattle continued to arrive. (National Archives, 106-FAA-90B.)

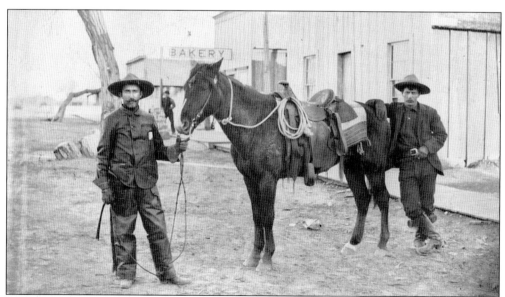

With the Hashknife came F. A. Ames (left) from the wealthy Massachusetts shovel-manufacturing family. His father was heavily invested in the Aztec company, and the son came west to work the cattle—with a camera in hand. Ames poses here with Ed Rogers and the horse Dandy. Rogers was the boss of the Hashknife's east, or Apache, herd, which he skillfully managed until 1888. (Photograph by J. C. Burge; NCHS.)

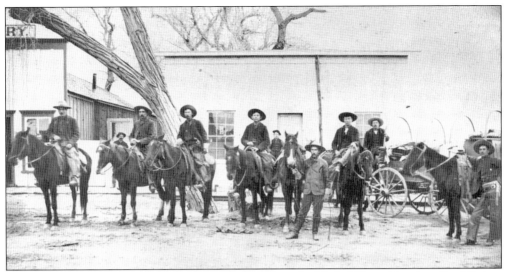

F. A. Ames photographed these unidentified men, whom he labeled "Aztec Punchers," saddled up and ready to ride in front of Holbrook's business establishments. Ames is standing in the center holding his horse's bridle. The Hashknife may have had 60,000 head of cattle in Arizona when drought began in 1890. Cattle died by the thousands. (National Archives 106-FAA-92A.)

Hashknife cowboys and outlaws were sometimes synonymous. Local folklore tells of one cowboy at the campfire suggesting, "Why don't we all tell our real names." Frequently using aliases, many were listed on payrolls as Shorty Smith or Slim Jones. (Maryann Coulter.)

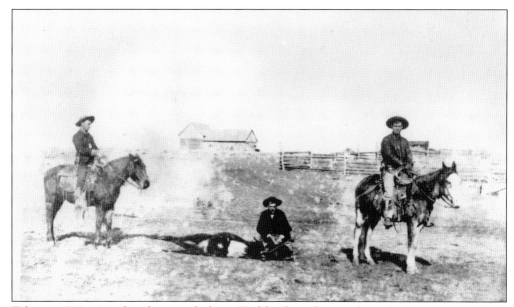

Taken in 1890–1891, this photograph shows Hashknife cowboys with a calf whose front and back legs have been tied in preparation for branding. Alberta Henning, living in Pinto, sent a postcard with a similar scene to her brother Lloyd in 1909. However, on the postcard, there is only one horse and the cow is tied only by its hind legs. Alberta wrote, "This must be a dead cow she is so still." (Albert Levine.)

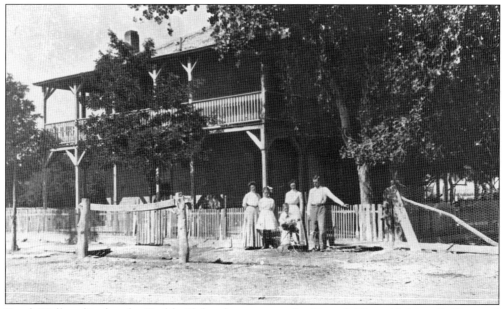

Frank Wallace lived at the Hashknife headquarters south of Joseph City with his wife Cora and five children. Relations between the Hashknife and the Mormons were somewhat strained—until 1903 when Cora desperately needed a midwife. A cowboy was sent to Joseph City, and Mary Richards came, saving both mother and baby. The baby, Anna, later married Charles Lisitzky.

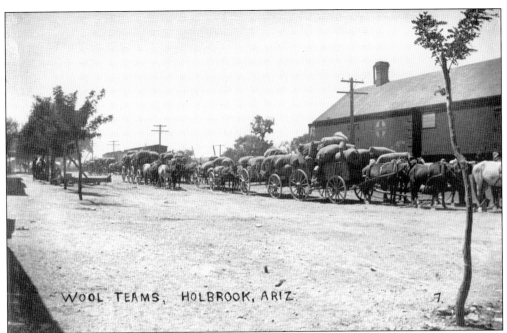

"WOOL TEAMS, HOLBROOK, ARIZ."

Northern Arizona ranges were grazed not only by cattle but also by sheep. The Babbitts, Daggs, and Tewksburys all ran large sheep herds from Flagstaff to the White Mountains. Hispanics in Concho also had large flocks. Both sheep and wool were shipped from Holbrook. As the newspaper reported in 1886, "Trouble is brewing between the sheep raisers of Apache county and the Aztec Cattle Company. The company recently [drove sheep off railroad-leased land. The] sheep men claim this action was unjust and high-handed. Trouble is likely to occur at any time between the representatives of the two interests, as a very bitter feeling exists." This became a full-fledged feud between the Grahams (cattlemen) and Tewksburys and became known as the Pleasant Valley or Tonto Basin War. It occasionally spilled over into Holbrook.

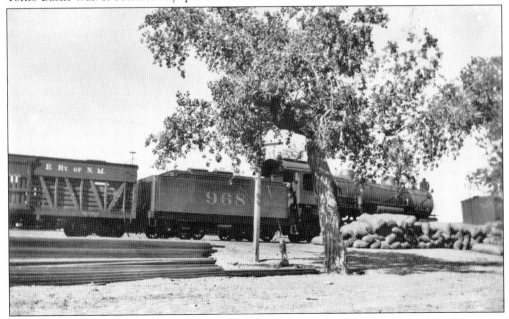

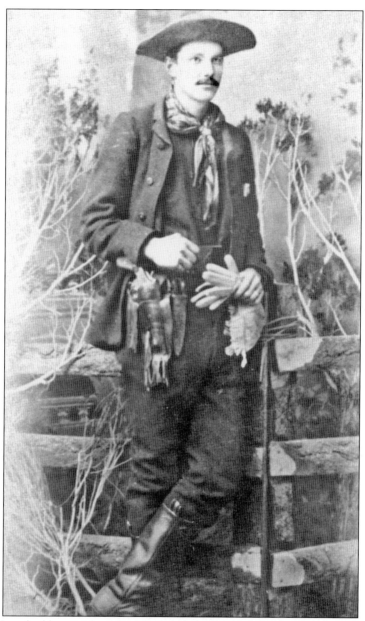

"Three Men Lynched by a Mob of Outlaws" read the headline in the *Apache Review* in August 1888. The hanging of James Stott, James Scott, and Billy (sometimes listed as Jeff) Wilson has been endlessly revisited. Stott (above) was born in Massachusetts in 1863 and arrived in Texas in 1883 to begin work on a cattle ranch. By the fall of 1885, he was in Holbrook and purchased a homestead claim 40 miles south for a horse ranch. Three years later, he was about to prove up his claim, and possibly someone wanted his land. He was also accused of horse stealing. Allegedly he told F. A. Ames, "Some people have judged me guilty without taking the trouble to investigate the charges or giving me a chance to defend myself." Regardless of the reason, a party of unknown people showed up at his ranch, took the three men down the trail, and hanged them from a large ponderosa pine. Scott and Wilson seem to have simply been at the wrong place and the wrong time. (Leland Hanchett Jr.)

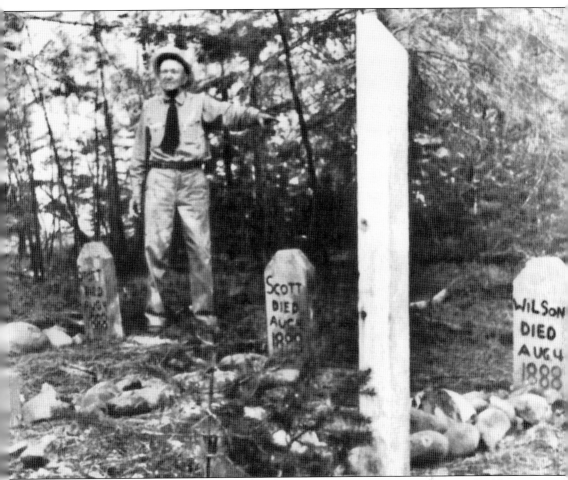

We know less about James Scott. John Addison Hunt said, "He was small and we called him 'The Kid.'" A Hashknife cowboy, Scott became fascinated with Nellie Cross, living in Woodruff. "Scott used to stop to see her when he came to town for the mail," said Hunt. "He also attended the dances and parties at Woodruff . . . and tried hard to win her affections. But it was my good fortune to be trying the same thing and I beat his time." Years later, John Addison Hunt showed his son Ben the graves. In 1955, Ben Hunt (above) was a Navajo County supervisor and "had a little time on my hands recuperating from a heart attack." He made three headstones from concrete and "marked them with the dates of their death, August 4, 1888. John Miller and a few friends went with me and we went up and marked these graves. . . . The reason I did it was largely because my dad knew these fellows . . . and he knew that it was strictly a mob rule." (Don Dedera.)

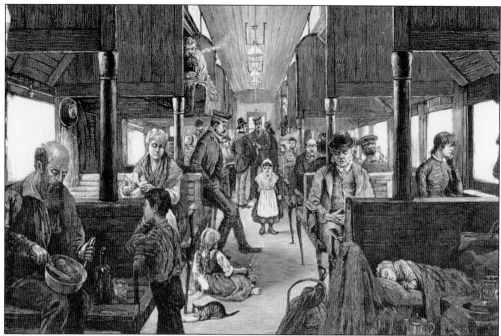

Francis Zuck arrived in Holbrook on the first scheduled passenger train from Albuquerque to Winslow. Accommodations were meager, with wooden seats that could be pushed together for beds and a community cooking stove. Most passengers brought their own boxes of food. This engraving reflects the boredom on a train creeping along at 20 miles per hour. (*Harper's Weekly*, November 13, 1886.)

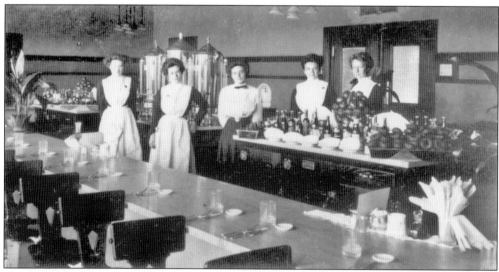

No one was more horrified at primitive dining while riding a train than Fred Harvey, who in 1878 opened his first restaurant in Topeka. In Holbrook, the Harvey House was five boxcars with peeling paint parked on a side rail. Inside, however, were clean linen and polished silver, as well as beautiful flowers and fresh food, both of which were made possible by railroad ice cars. About 1900, the Holbrook facility moved to Winslow (pictured above in 1910). (Old Trails Museum.)

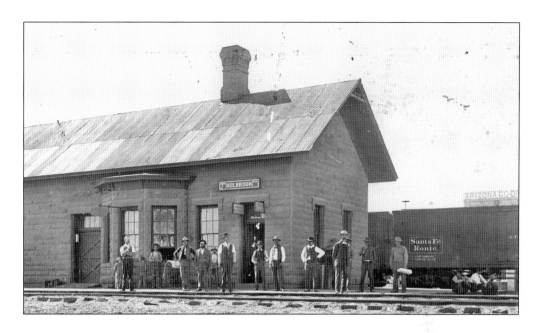

In New Mexico, the Atchison, Topeka, and Santa Fe Railroad joined the Atlantic and Pacific Railroad to build a joint line west. John McLaws of Joseph City noted in his diary, on October 23, 1881, "Went to Holbrook to see the cars, had the pleasure of seeing the first passenger train that has come over the road." The first permanent railroad station was built in 1882, but the depot illustrated here was built after the 1888 fire. The newspaper in 1895 stated that Holbrook was "the greatest shipping point for livestock and wool along the line of the Atlantic and Pacific Railroad between Albuquerque and the Needles. The shipment of cattle alone runs up to 20,000 head, and sheep, 18,000. As for wool, more than 60 cars were loaded at our depot."

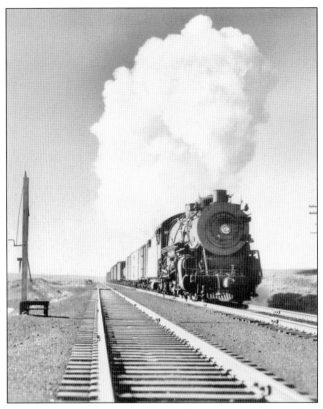

Both steam and diesel engines were used by the Santa Fe Railway in the 1930s. Above is an oil-burning steam engine west of Winslow in 1937. Steam engines were used, mainly for freight, until the mid-1950s. The pole held a sack of mail that an arm from the train could snatch as the train rushed by; the mailbag for this remote location was simply tossed from the train. The image below is of an EM Division General Electric diesel, photographed October 9, 1937, and named for its inventor, Rudolph Diesel. Diesel-electric engines gradually replaced steam engines after World War II. (Both photographs by Norman Wallace; AHS/Tucson PC.180. F183 No. 4651 and No. 4632.)

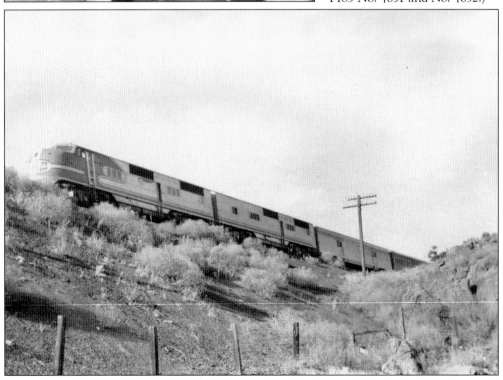

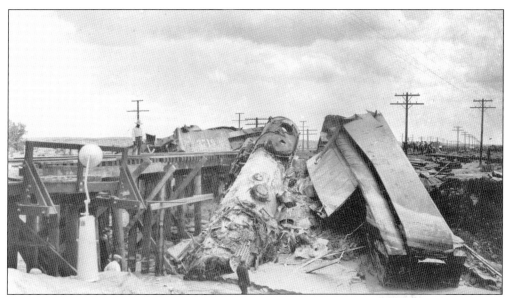

Automobile wrecks along Highway 66 were common; railroad accidents were rarer. This August 7, 1930, train derailment on Tanner Wash about eight miles west of Holbrook occurred because flooding had weakened the bridge supports. Engineer R. E. Bixby, and foreman M. D. Burney were killed when the engine and three baggage cars broke through the trestle.

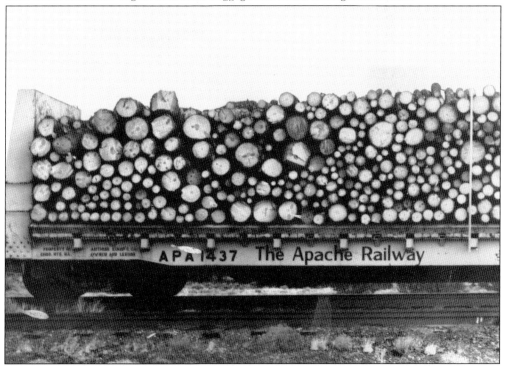

Work on a railroad spur began in October 1917 to connect Holbrook with a proposed lumber mill at Cooley (now McNary). The Apache Railway, completed in February 1919, ran twice weekly. Sometimes it carried passengers, but—as seen in this 1960s photograph—it mostly was used for freight; cattle and lumber were shipped out of the White Mountains. (Photograph by Max Hunt.)

Kenner Kartchner described bringing cattle into Holbrook for shipment to Denver in 1907: "Shirts, hats, Levi's, underwear, and socks were purchased at the stores and put to use after baths at the Santa Fe pump house east of the depot. . . . Thus cleansed, togged out, and freshly barbered a la Bill Cross, our general appearance was so improved we began calling each other 'Mister.' " (Maryann Coulter.)

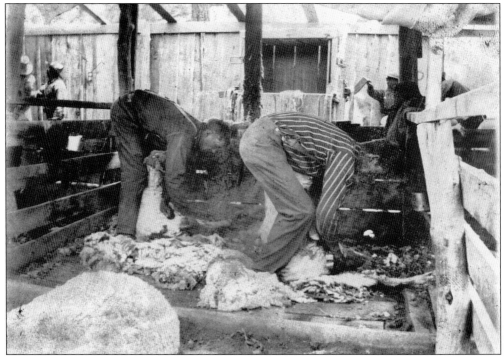

This image of sheep shearing for H. H. Scorse helps understand the song of an old sheepshearer, hands and back crippled with arthritis from hard work and bending over: "I'm one of the has-beens, a shearer, I mean, / I once was a ringer, I used to shear clean; / I could make the wool roll off like the soil from the plow, / But you may not believe me, because I can't do it now."

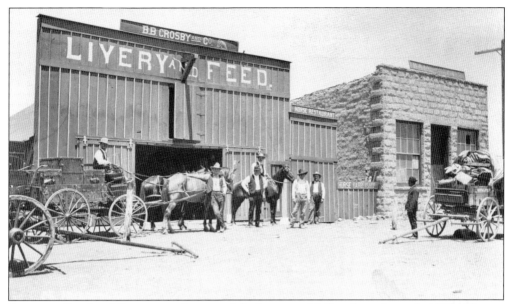

Benjamin Crosby of Eagar ran a livery and feed store in Holbrook in the early 1900s. He was also a grading contractor, cattleman, and wool grower. For his ranch near Eagar, he imported a railroad carload of Durham cattle, which by 1913 made his herd one of the finest in northeastern Arizona.

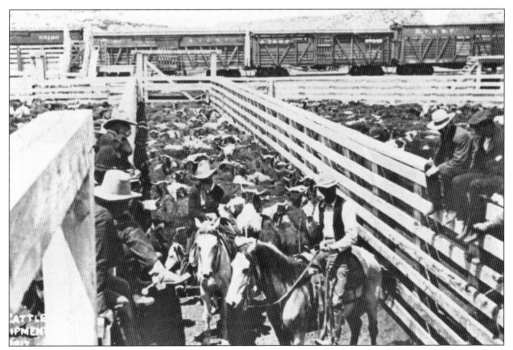

This image at the livestock yards in Holbrook is labeled "Inspecting Cattle for Shipment." Livestock inspection helped prevent the spread of disease, such as hoof-and-mouth, a threat to the cattle industry. Also, in an area of open range, cattle rustling was somewhat curtailed with brand inspection at the time of sale.

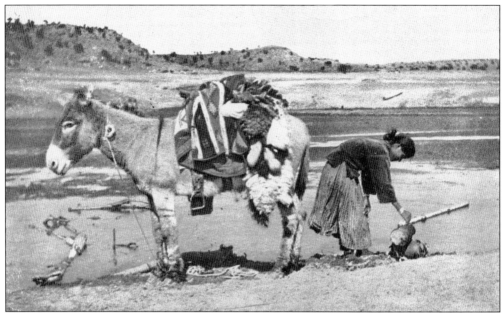

This burro carries water, but Kenner Kartchner told another story. After roping, branding, and dehorning maverick cattle, a camp-following burro was "necked up close to a bloody monster twice his weight. . . . Vicious dives at the burro were quickly countered by severe kicking and biting. . . . Thus the steer was soon humbled into strict obedience and yielded to the slightest tug on the rope as the burro's homing instinct came into play." By evening, each "team" arrived at camp.

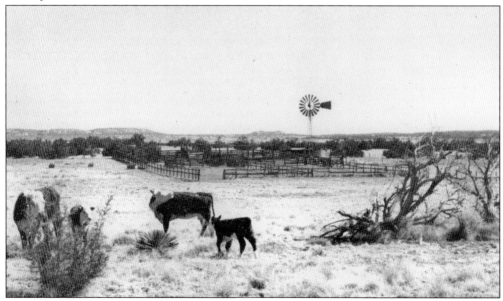

The adage "You can kick a man's dog, or you can steal his wife, but you'd better leave his water alone" comes from the arid West. Windmills became a solution. With troughs and corrals, these locations were used to capture wild cattle, but the wary animals would only approach at night. "They smelled that precious water a mile away," wrote Kenner Kartchner, "but closer in, the taint of man corrupted its sweetness." (Photograph by Max Hunt.)

Four

A Civilized County Seat

Navajo County was carved out of Apache County in 1895, and Holbrook became the new county seat. An appropriately impressive courthouse was built, but Holbrook was still known for its brawls and shoot-outs. The newspaper reported that Holbrook "had the distinction of being the only county seat in the U.S. without a church." A common meeting place, the Bucket of Blood Saloon, had proprietors with anti-church sentiments, and some thought they even influenced the cowboys against religion.

Local attorney Sidney Sapp began raising money for a Methodist church in 1912. When asking for donations, he explained that he wanted it "so families [could] be induced to come here and make their homes." The response was, "Who wants to bring women and children here? This is a man's country." When Sapp replied that his wife wanted to attend church, he was told, "Send her back to Oklahoma if you want her to go to church." However, a Methodist church was completed in 1913 and was soon followed by a Mormon church and an Episcopal church, complete with a hall for the Girl's Friendly Society, a social and service organization. In 1915, Fr. G. O. Max became the first resident Catholic priest. He built a small adobe rectory and church, Our Lady of Guadalupe Catholic Church. Holbrook would no longer be served only by itinerant preachers.

The Bucket of Blood Saloon eventually went out of business, if not because of church influence, then because even the cowboys became tired of crooked gambling and murders. "The death blow to the saloon," remembered the newspaper in 1935, "was struck one morning when a patron started through the swinging doors and saw two men, one lying across the other, on the floor. They had both been shot and the place was empty of living souls. The bartender had fled, fearing that he could not clear himself of the charges of murder."

Holbrook was ready to become civilized.

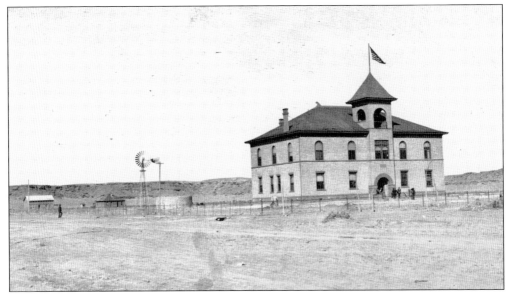

Will C. Barnes came to Holbrook in 1883 and began ranching at the Esperanza. He introduced a bill to divide Apache County and was successful on March 22, 1895. Barnes wrote, "Many in Holbrook wanted to call it Colorado County but I was determined it should have an Indian name and stuck to Navajo spelled with a 'J' at that for I despised the idea then prevalent of using the letter 'H' for the Spanish J." In 1896, bonds were approved for a courthouse that was constructed of locally manufactured brick on a Moenkopi sandstone foundation. It currently houses the Navajo County Historical Society and chamber of commerce. Below, Ellen Scorse poses with her boys (from left to right) Harry, Winston, and Richard around 1917. (Maryann Coulter.)

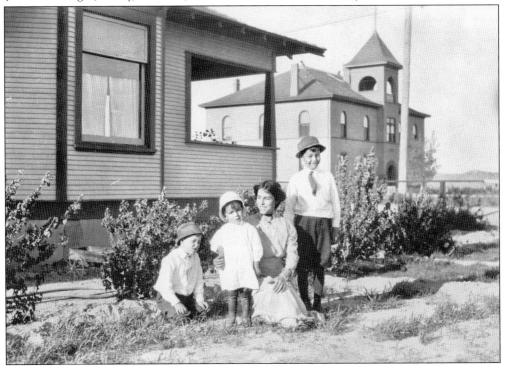

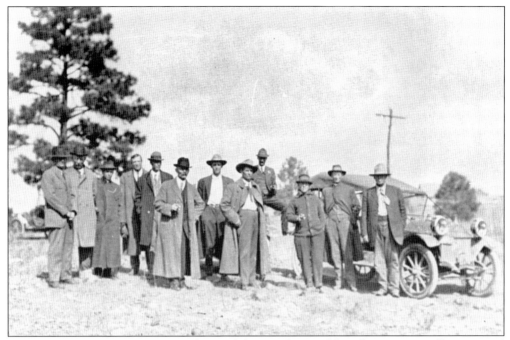

County business and politics centered around the courthouse, although many men still announced their candidacy on the steps of the Bucket of Blood Saloon. Political candidates are seen here on tour of the county (presumably in the White Mountains) in the early 1920s. Some of the men are (counting from left) No. 1 Glen Heward, No. 4 Jesse Crosby, and No. 10 Joe Gerwitz.

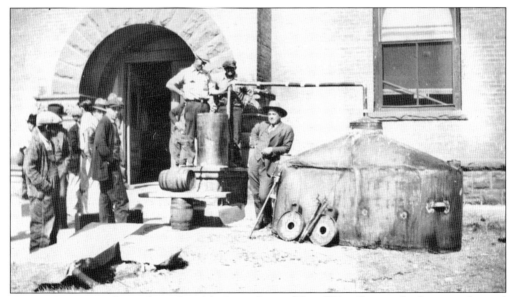

Navajo County tried to enforce the 18th Amendment (Sheriff Divelbess with a huge confiscated still, no date). In 1928, the *Holbrook Tribune-News* reported: "In a raid conducted late June 8, Sheriff L.D. Divelbess and Undersheriff O.C. Williams discovered a cache of approximately 65 gallons of moonshine liquor concealed under the floor of the old city hall building at the west end of town."

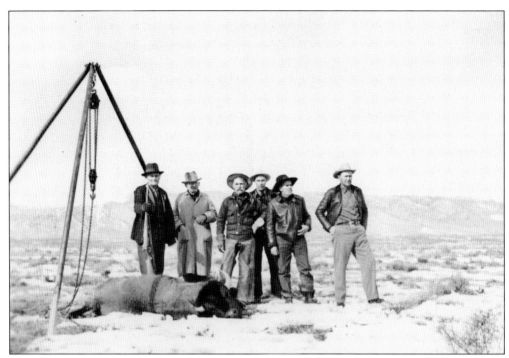

In January 1940, 70-year-old John Addison Hunt was one of 55 men drawn for a buffalo hunt at House Rock Valley. This was the first hunt since the Arizona herd had been established about 50 years earlier from Texas stock. Hunt returned with the head (which was hung in the courthouse) and a quarter of the meat. *Life* reported, "It was difficult to miss and, as a sport, reminded hunters of shooting cattle in a backyard." The men above are, from left to right, John Addison Hunt, unidentified, "Uncle Billy" Crosby (caretaker of the herd), Ben Rencher, unidentified (possibly skinner Ray Abbeloos), and Ben Hunt. The parade below (no date) illustrates patriotism and pride in country after Arizona's admission to the Union in 1912. (Above Bruce Hunt; below NCHS.)

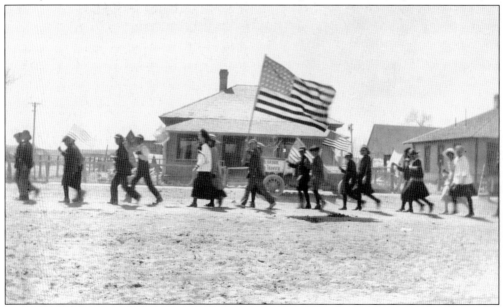

Judge Sidney Sapp, born in Illinois in 1868 and practicing law in Missouri and Oklahoma, came to Holbrook in 1909. In 1912, he was appointed the first judge of the superior court under statehood. Sapp married Alma Spiers in 1910, and they combined families. She had two children, Irene Whetstone and Leon Spiers, and Sapp's daughter Helen came to live with them. In 1914, baby Gwendolyn was born. Shown with his family (above c. 1914 and below c. 1917), note that a second story has been added to their house before the second photograph. As a lawyer, Sapp was instrumental in helping Civil War widows receive pensions, and in private life, he was grand master of the Free and Accepted Masons.

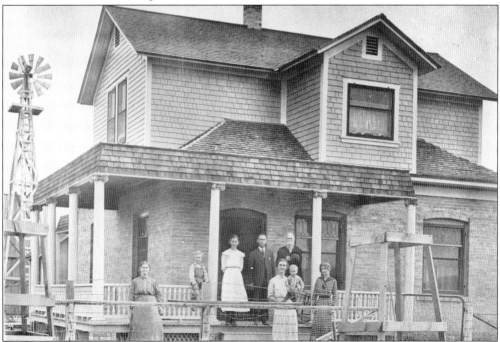

Jesse E. Crosby, Navajo County judge from 1919 to 1931, is pictured in the law library at the courthouse. The law volumes lining the walls are occasionally used by Navajo County attorneys today. Crosby graduated from the St. Johns Academy, attended Utah Agricultural College, and trained for the law at the University of Michigan at Ann Arbor.

Courthouse personnel in 1927 included, from left to right: (first row) Don Udall, Roy Cross, Judge Jesse Crosby, recorder Lucretia Flanigan, Bronson Crosby (son of Jesse), and secretaries Roberta Tandy and Dorothy Calhoun; (second row) unidentified, Undersheriff O. C. Williams, Treasurer Wallace Ellsworth, County Attorney P. A. Sawyer (later judge), and Sheriff L. D. Divelbess. Many held other county offices later; for example, Don Udall was county attorney from 1933 to 1938 and judge from 1945 to 1963.

Holbrook was part of District No. 1 when electing a supervisor. In 1932, Lloyd C. Henning, age 46, ran on the Democratic ticket. His father operated a cattle ranch east of Holbrook, and Henning said, "I have been on 'day herd' as a kid." Henning described himself as having received most of his schooling in Arizona, " 'graduating' about the seventh grade in Holbrook in 1902." He married Esther Hess (above) and worked with the newspaper, bank, and telephone company, and in insurance. Henning won the election ("Made it by 56 votes. Busy, Busy, BUSY.") and served until 1936. His next public office was that of state senator from 1941 to 1949 (below). Henning also helped establish the Masonic lodge in Holbrook. (Above NCHS; below photograph by Herb McLaughlin, Arizona Collection, ASU Libraries, CP.SPC.177.75.)

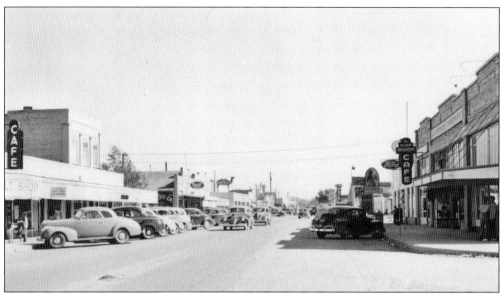

Holbrook revolved around county business as done by the board of supervisors. When Sheriff Divelbess died in 1949 only 46 days after taking office, the board appointed Ben Pearson as his replacement. People wanting liquor licenses appealed to the board and were often denied. The supervisors added voting precincts (Indian Wells and Hotevilla) and dissolved school districts (Zeniff and Shumway). In 1944, they contracted with the Silver Moon Cafe (above) to provide prisoner meals for 38¢ per meal. The main duties of the board were fiscal, allocating money for pest control, utilities, hospital and burial fees for indigents, jail expenses, and roads—mainly roads that were mostly dirt and needed regular grading (below). (Above photograph by Norman Wallace, AHS/Tucson PC.180.F236No. 0208-7; below photograph by Max Hunt.)

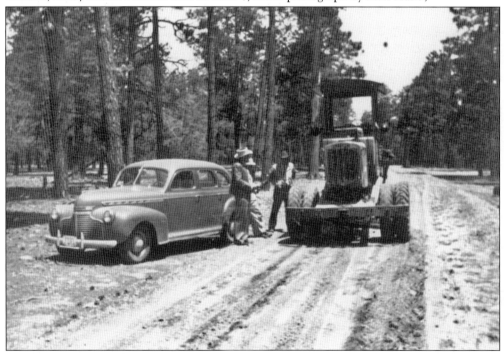

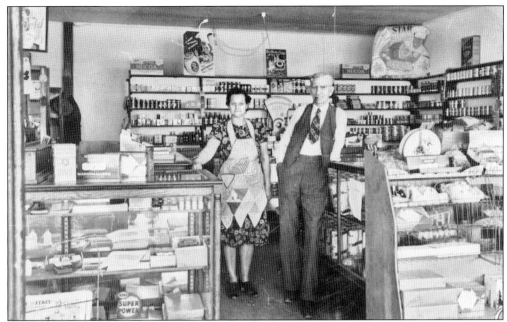

When the Aztec Land and Cattle Company no longer shipped cattle from Holbrook (by 1901), Holbrook citizens began looking for other revenue. Some continued to supply dry goods and groceries. Mr. and Mrs. W. S. Dyer (above) are seen in their store, the White Grocery. All soups were the same price, so many in the community ate vegetable beef instead of tomato. Below is the T. J. Koury store, which was in the old Wattron Drug building. T. J. and Florence Koury emigrated from Lebanon about 1904 and gradually moved west. They lived in Georgia, North Carolina, and New Mexico, and finally came to Arizona in 1916. With a large family, they soon became an asset to the community.

One cattleman continuing the ranching tradition was Hyrum Hopen, who was originally from Missouri but lived at Pine Dale. The relative prosperity he achieved can be seen in this photograph of his daughters, Ellen Hopen Hancock (standing left) and Viola Hopen Ruth, probably taken c. 1911 when Viola lived in Holbrook. Presumably, the woman seated is his wife, Emma. Viola rode with both a rifle and pistol at her side as a girl. One day some Apaches approached her and insisted she shoot a squirrel with the rifle. Down the trail, they insisted that she shoot another squirrel with the pistol. Apparently satisfied that she could indeed shoot, both Viola and the Apaches continued toward her father's ranch, where the Apaches were given food. Viola was also an expert fiddler.

This adobe schoolhouse (25 feet by 45 feet) was built in 1885 on the banks of the river, and elementary classes began with a Mr. German as teacher. The next year, Estelle Herstein taught (and later married Frank Wattron). She had 27 children attending, although the newspaper thought that twice that many children resided in town. A free public school was considered a credit to the community.

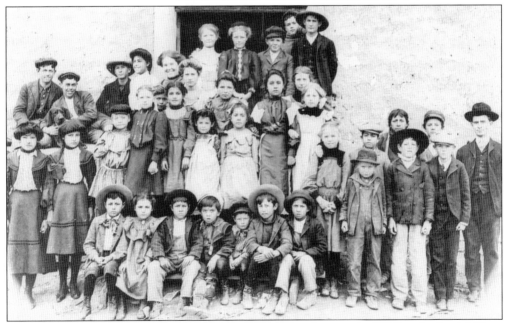

In 1898, Holbrook's school was divided into two classes. This photograph of Holbrook schoolchildren has no date. Many children have been identified; William Jones of Flagstaff (far right) was the teacher. In 1910, a new school was built and named Central School, later known as Sheldon. Three classes were held in it, and the adobe schoolhouse was used for Hispanic children for a short time.

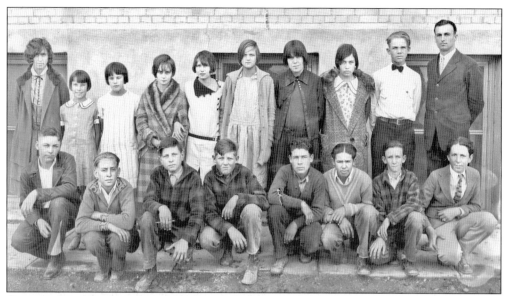

Garnette Franklin (standing fifth from left) donated this photograph of the 1928 Holbrook eighth-grade graduating class; Helen Wells (standing left) and Paul Plummer (standing right) were the teachers.

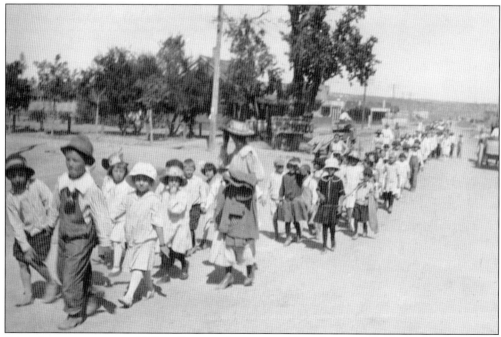

Several women came to Holbrook as teachers, married, and contributed significantly to the community. Foremost of these women was Esther Hess, born and educated in Ohio. She taught in Holbrook for one year, then married Lloyd Henning and continued teaching four more years. However, she was always concerned about the children of Holbrook. This image of a parade of unidentified children was found in her husband's papers. Her 1940 obituary noted, "Her greatest dream was a recreation center for the children of Holbrook." (Arizona Collection, ASU Libraries, CP.SPC.177.73.)

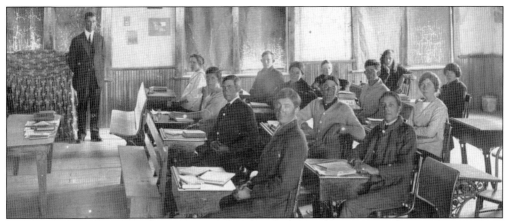

Finally in 1917, a new building was completed and Holbrook had a high school, with accreditation in 1921 and the roadrunner as mascot. (NCHS.)

Top row: Gilbert Richards, Amy Thompson, Malcolm Rogers, Joyce Scott, Russell Westover, Daisy Swatzell, Carl Jacobson. Bottom row: Verdo Mathias, Lily Koury, Max Hunt, Mary Sherwood, Raymond Randall, Beth Perkins, Lester Grace.

The students began a monthly newspaper, *The Sage Brush*, in 1928. Garnette Meadows designed the masthead; it was published into the 1940s. In 1933, the high school consisted of about 100 students and had a graduating class of 13. Max Hunt remembered, "We lost every [football] game. Gallup, New Mexico, beat us 60 to 3. Toward the end of the game, our quarterback, Carl Jacobsen, kicked a field goal. I can still remember looking up from the bottom of the pile and seeing the ball sail through the goal posts." (Max Hunt.)

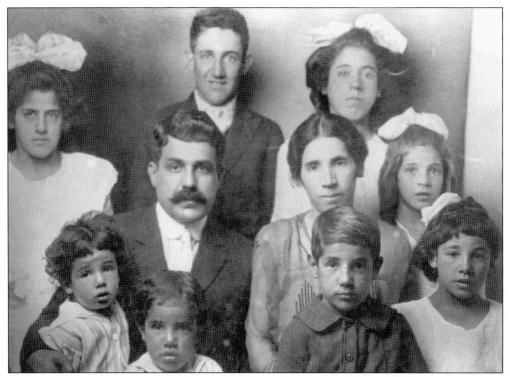

Two special teachers were Letife Koury and LeRoy Gibbons. Koury, shown here with her family, taught in Holbrook from 1928 to 1973. In 1985, she was included in a list of 100 Arizona educators honored at the centennial for Arizona schools. She gave countless hours tutoring underprivileged students, promoting facility improvement, and preparing students for universities.

Gibbons taught music and would say, "Teach a boy to blow a horn and he'll never blow a safe," undoubtedly a response to the desperate Depression years. He trained many award-winning marching bands. Zena Hunt wrote, "If it weren't for Mr. Gibbons, Holbrook would have been a pretty dull place. No library, no park, no organized ball games, no bowling alley. But the school music program gave us all something to do."

One unique logo from Holbrook was the camel in front of Campbell's Coffee House. Originally owned and operated by Frank Campbell, schoolchildren could drop in for a "bowl of red" (chili) and a piece of apple pie. (Photograph by Garnette Franklin.)

Another eating establishment was the Rees Cafe (and Greyhound bus depot), owned and operated by Frank and Bertha Rees (photographed here with Ruby Adams, left). Bertha also taught school in Joseph City, where the townspeople "liked her very much," remembered Louise Tanner Gerber. She described Bertha as "very pretty with lots of charm as well as teaching capabilities. . . . Mrs. Rees inspired class members with the great American dream that we could do and become whatever we wished if we worked with determination. Our class motto was 'No victory without labor.'"

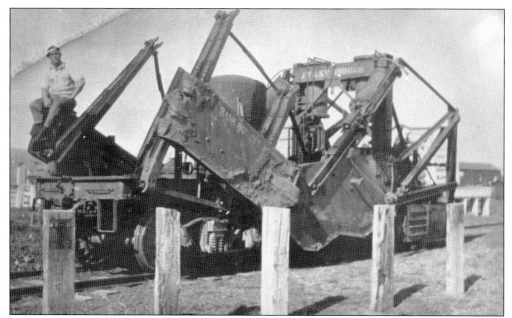

In 1918, oil fever came to Holbrook. Geologists thought the Holbrook Anticline was an indicator of petroleum deposits, so hopes were high for both local residents and outside speculators. Nearly every edition of the newspaper carried oil field news, and the slogan "Heart of the New Oil Field" was added to the newspaper. No oil deposits were found, and the slogan was dropped after nearly 10 unprofitable years. Oil-drilling rigs were brought into northern Arizona on railway freight cars, as in this undated photograph at Adamana.

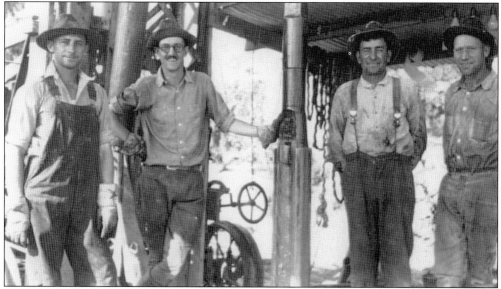

This later oil-drilling crew includes, from left to right, Claude Flanigan, Robert Greer, unidentified, and Elmer (Jack) Flanigan.

Oil companies tried again in the early 1940s. Pearl Hunt wrote, "I'm getting a little faint hearted about the oil wells in this vicinity. They had a contract for a 4000 ft. well but when they were down about 3500 [feet] one of their motors burned out, [and] while waiting for repairs their tools became fast in the well. It was impossible to get them out (about $40,000 worth) so they abandoned it and started another well about 10 miles from the first one." The companies tried for oil once again in 1948–1949 (with a similar lack of success). These images are from a drilling near Holbrook. (Both Bruce Hunt.)

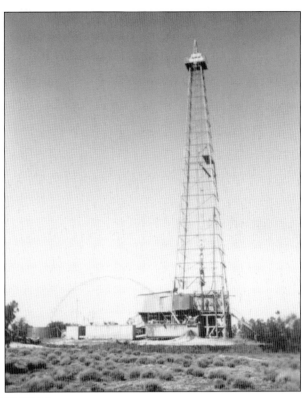

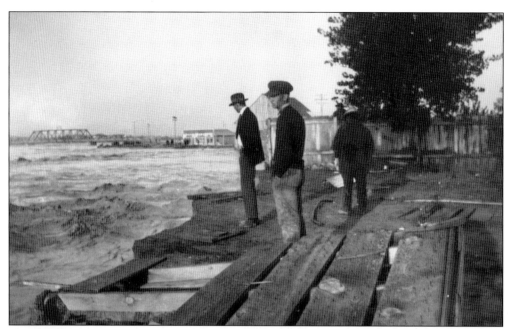

Flooding became a concern on the Little Colorado River after a buildup of silt left the riverbed almost higher than town. The worst floods occurred in 1904 and 1923 (above). "With all trains . . . tied up due to washouts," reported the *Arizona Republican* on September 19, 1923, "state highways made impassable, [and] telephone and telegraph service broken, the entire northeastern portion of Arizona east of Flagstaff has been practically cut off from the rest of the state due to the continuous rains which have fallen . . . for more than 30 hours." At Holbrook, one person drowned while trying to swim the river, and several buildings were washed away. Dams at Lyman Lake, Woodruff, and Joseph City were washed out (the last only partially). In the undated photograph below, people on the Holbrook bridge watch the water rush by. (Above NCHS; below Arizona Collection, ASU Libraries CP.SPC.177.59.)

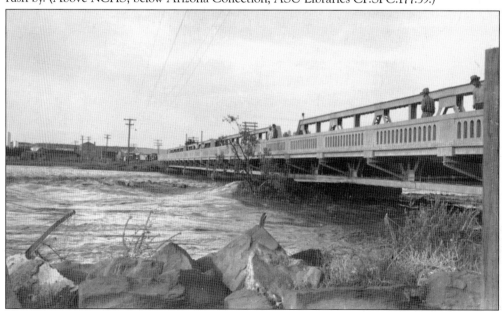

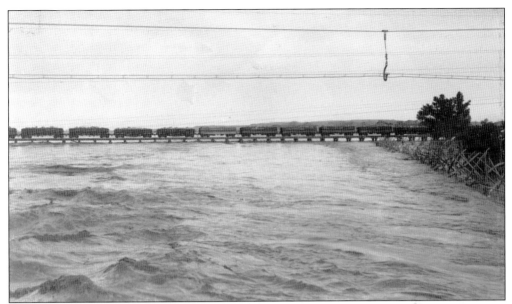

Problems with flooding were addressed in the 1930s and 1940s. In this undated photograph, railroad cars use the bridge to cross over the swollen river. Railroad bridges were as vulnerable to flood damage as highway bridges. (Arizona Collection, ASU Libraries CP.SPC.177.58.)

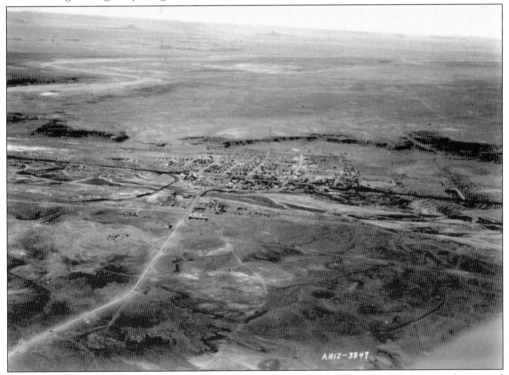

This aerial photograph looks north toward Holbrook. It was taken January 12, 1938, and was used to show the flood menace to the town and railroad. The Army Corps of Engineers constructed a protective dike in the late 1940s. The next flood in August 1957 washed out the Apache Railway Bridge, but the dike prevented flooding in town. (Photograph by H. G. Calkins; AHF QF-13.)

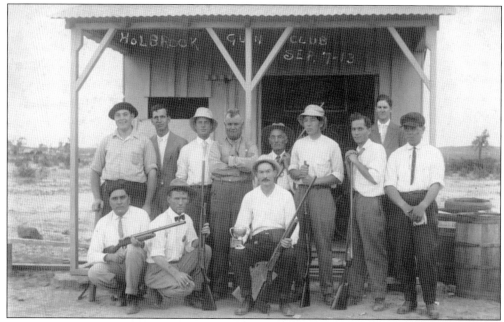

With shotguns in hand, the Holbrook Gun Club poses September 7, 1913, for their photograph at the First Annual Trapshooting Tournament. Presumably Dick Grigsby won the shooting that day (note cup in hand). From left to right are (first row) Charley Cooley, unidentified, and Dick Grigsby; (second row) unidentified, Jones Grigsby, John Miller, W. R. Gardner, W. D. Easley, C. C. McCleve, Jess Hulet, unidentified, and Henry Lee. Tournaments were also held in 1914 and 1915.

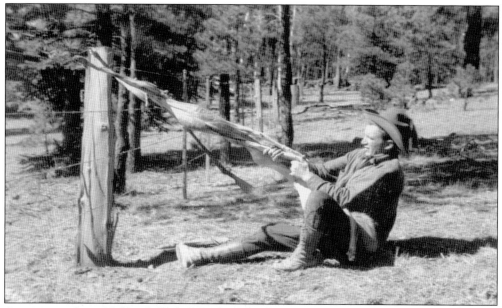

A generation later, Holbrook High School graduates were still using guns for recreation. Shown here are the results of a 1938 hunting trip to the White Mountains, with Raymond Randall from Joseph City skinning a coyote. Max Hunt took the photograph and wryly noted, "The hide might pay for the shells (13)."

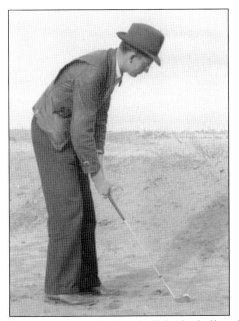 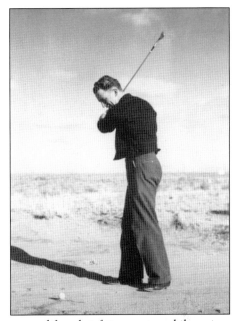

Recreation included baseball, basketball, rodeos, dances, and for a brief time, automobile racing. Golf was introduced and promoted by John Miller in the mid-1930s. The 1937 photograph on the left shows Vance Miller blasting out of a trap. Raymond Randall is pictured at right on a golf course with no grass. Dust was kept to a minimum by adding a little oil to the surface of the ground. (Both photographs by Max Hunt.)

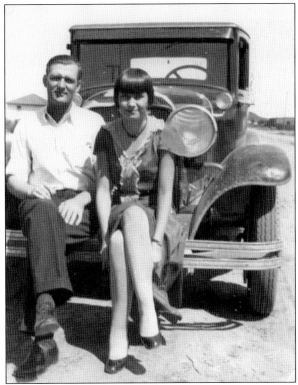

A Holbrook couple, Ted Gerwitz and Garnette Meadows, are sitting on a 1928 Chrysler New Yorker. Garnette wrote, "If a couple had only two dollars for a license, they were married by a Justice of the Peace or a minister and stayed in town. Those a little more affluent 'eloped' and went out of town to be married." Ted and Garnette were married in Albuquerque in 1930. (Gail Taylor.)

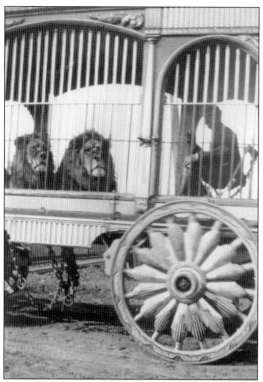

The Scorse family saved a series of circus photographs taken in Holbrook; they are probably from 1888 (Jesse N. Smith's journal). Another circus came to Holbrook on October 20, 1911. May Hunt Larson wrote, "We saw the circus elephants, camels, well trained horses and riders. There was a street parade at ten and performances in the afternoon and evening. We all went in the afternoon." (Maryann Coulter.)

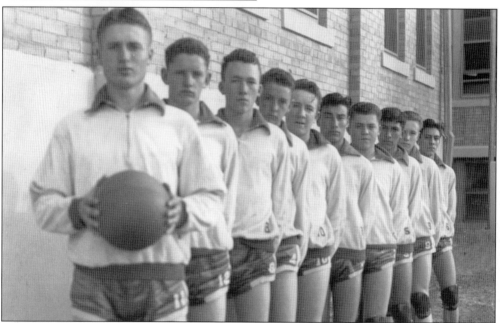

The high school basketball team in 1941 included, from left to right, Alfred Heward, Lee Kutch, Bruce Hunt, John Kutch, Bobby Morris, Pete Garcia, Dave Ortega, Johnny Gallegos, Orlin Hatch, and Aurelio Angeles (called "the Mormons and the Mexicans" by the community). Heward, Hunt and Gallegos were seniors; the others were sophomores. By 1943, Holbrook had an outstanding basketball team, but a state tournament was not held because of the war. (Bruce Hunt.)

Distribution of mail to Woodruff, St. Johns, Show Low, and Snowflake always started at the Holbrook depot. Above, Lynn DeSpain is preparing to deliver the mail in the early 1930s. Cecil Swatzell, freight foreman for the railroad, is standing outside the car. Below, Edgar Burton and Ed Ellis (from Texas) formed the Holbrook Transfer Company to deliver supplies brought on the railroad. Their fleet of International Harvester trucks and cars bridged the gap between six-horse, double-wagon deliveries of the late 1800s and the Smith-Heywood lines in the 1950s and later Thunderbird Freight.

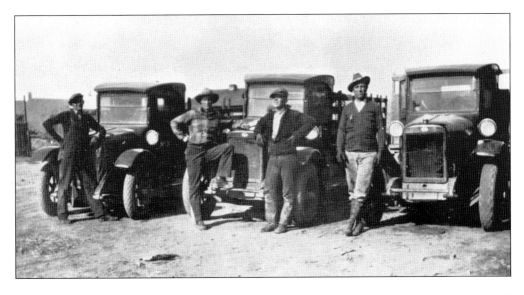

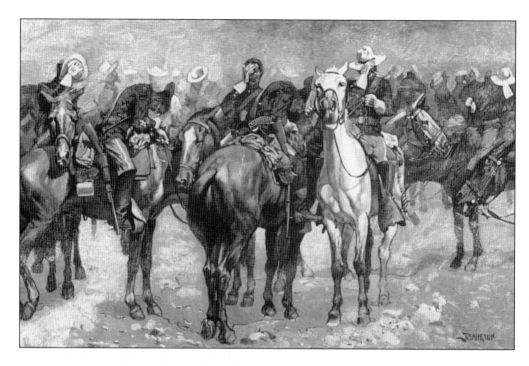

A windy day in Holbrook means spring has arrived. Above, an 1889 cavalry troop is halted because of an Arizona sandstorm. In 1911, a Holbrook visitor wrote: "Very hot and dusty here. This place is the home of sand storms. We are having one this a.m." During World War II, Beatrice O'Connell and Cheryl Hatch joined the WAVES and were stationed in Hunter College, New York. They missed "the old home town and all our friends," but more surprisingly, they were "lonesome for a good sandstorm" (bottom, 1838). Beatrice Papa of Snowflake began her poem "Windstorm" with "If we could tame the wind, / we could feel spring's gentle touch." She was realistic, however, and ended the poem, "The sun and the wind are both ancients. / In March, we know only the wind." (Above Frederic Remington, *Harper's Weekly*, September 14, 1889; below photograph by Max Hunt.)

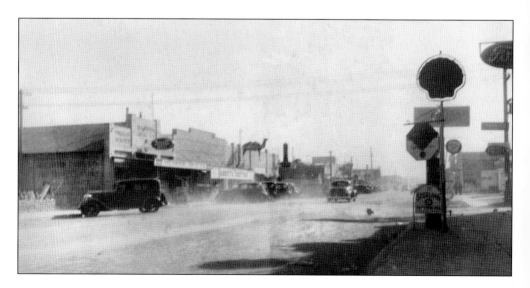

Margaret Candelaria represents Holbrook's proud Hispanic heritage; many Hispanics moved back and forth from Concho and were associated with raising sheep. A daughter of Manuel and Prudence Candelaria, Margaret was born around 1914 and married Morris Vesper in 1935. The recipient of this photograph, her "pal," is unidentified. Juan Candelaria was another important sheep rancher living in Holbrook during the 1930s.

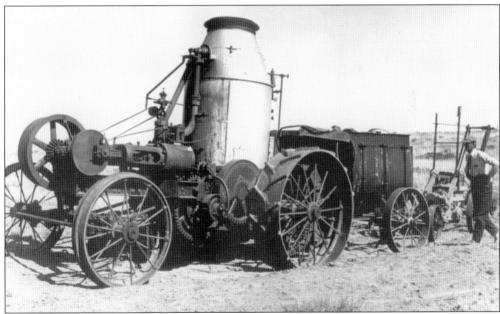

This steam traction engine was used around Holbrook during the 1920s. Wood and water were transported in the trailer, steam ran the flywheel, and an 8-inch-wide belt connected to the farm machinery. Bruce Hunt, telling about a similar engine, said, "As I recall, there was only one silage cutter in town, maybe two, and it moved from farm to farm." (Photograph by Leo Crane; Cline Library NAU.PH.658.74.)

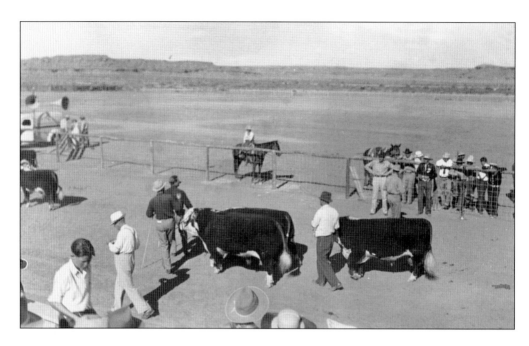

In 1935, local cattlemen and Holbrook townspeople called a truce. The cattlemen, represented by William Bourdon and Leo Frost, believed that the townspeople had forgotten the old glory days when cattle shipped from Holbrook were the mainstay of the economy. They suggested holding a "Round-up Jubilee" in conjunction with federally required tuberculosis testing the end of May. This would not be a rodeo with professional stunts but would include horse races, bull exhibits, cutting-horse and wild-mule-roping contests, and finally a barbecue and old-time dance. Local businessmen provided many of the prizes, making the event wildly successful. Racehorses came from California, Morgans and Arabians from Tucson, and the U.S. Army sent its finest stallions. The stockmen's show was later combined with the county fair, seen here in 1938.

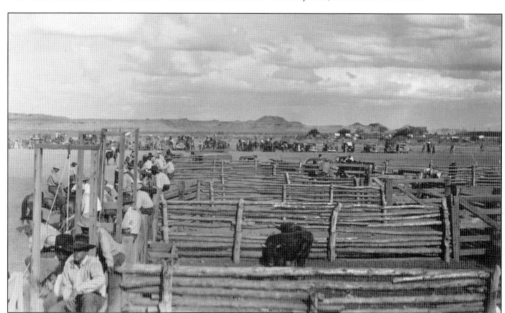

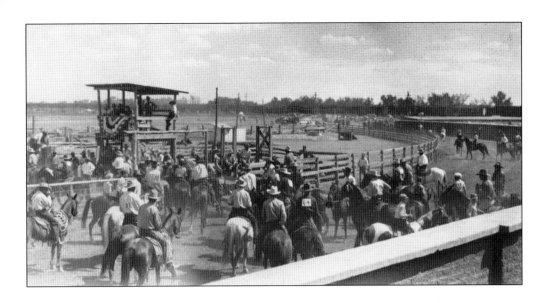

The WPA completed a new grandstand and racetrack in 1938. In 1935, Leo Frost suggested that "every cow pony in the country" would attend, and he may have been right in 1938. The horse roping in front of the grandstand (below) is the bed-pack contest. Horses were penned with a rope corral, and then each contestant laid out his bedroll and saddle on the ground. "At the sound of the gun," the newspaper announced, "they will jump up, put on their boots, roll up their beds, grab their saddles and ropes and run for the corral. One of their saddle horses will be saddled and the other will carry the bed roll. The first cowboy who goes around the track leading his pack horse will be the winner." In 1935, that was Hy Richards.

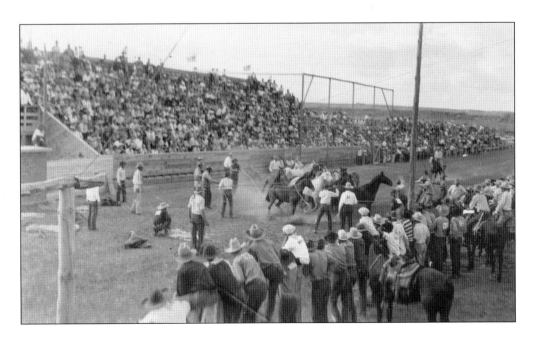

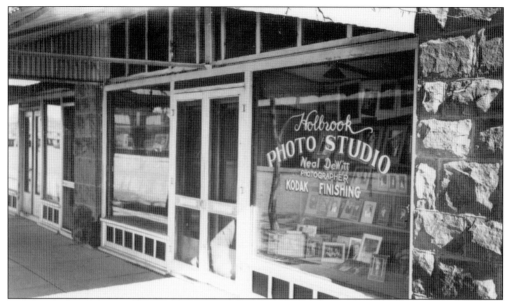

Photographers, itinerant and resident, known and anonymous, have documented Holbrook's history. Early photographers included Loui Ghuey, F. A. Ames, W. Calvin Brown, Robert Clark, F. W. Middleton, and George Lyman Rose. This image of Neal DeWitt's studio is from the late 1930s. More recently, Garnette Franklin and JoLynn Fox have photographed many events and people. (Photograph by Max Hunt.)

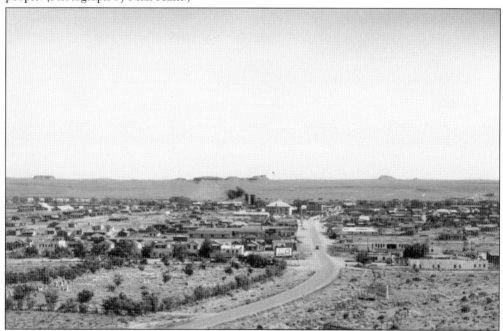

As viewed from the north about 1943, this is the Holbrook of Route 66 fame. Note billboards for the Navajo Hotel, Schuster's Gas, and Auto Court. The fairgrounds are on the extreme left, the courthouse is in the center, and the highway parallels the cemetery. Today the cemetery is walled with trees and lawn; the old section, however, is still traditional Spanish with no grass and plain crosses. (Photograph by Norman Wallace; AHS/Tucson PC.180.F236No. 0070.)

Five

ROUTE 66 AND THE PETRIFIED FOREST

Although John Steinbeck's geographical description was not very accurate in *The Grapes of Wrath*, he did describe the many families who came through Arizona looking for a better life:

> They climbed into the high country of Arizona and through a gap they looked down on the Painted Desert. A border guard [agricultural inspector] stopped them.
> "Where you going?"
> "To California," said Tom.
> "How long you plan to be in Arizona?"
> "No longer'n we can get acrost her."

During the Great Depression, Arizona's 376 miles of Highway 66 hosted many uprooted families. Allen Hensley, who ran a Whiting Brothers gas station, said, "Some people were having it pretty rough getting through the country. They'd break down or have flat tires. A lot would want to work long enough to pay for their gas or tires or whatever, and then they'd go on." Many in Holbrook became "a friend to man" as noted in the poem "The House by the Side of the Road."

As the railroad arrived, tourism increased, bringing visitors from around the world. One visitor, Rev. H. C. Hovey, who was traveling east in 1892, wrote, "Holbrook was the place where I was told to leave the cars and take a stage for the park. But there was no stage, and the sand storm that was raging at the time was such as no man who valued his comfort and safety was willing to encounter." Arranging for the conductor to let him off the train near Adam Hanna's ranch, Hovey borrowed a horse, photographed the petrified wood, and wrote about his adventure for *Scientific American*. "Each crystal, or moss agate, or amethyst, or onyx, seems most desirable," he reported, "till it lies in your pocket or saddle pouch, and then others assert their superiority."

Tourists taking petrified wood have always been a problem. This letter dated April 2, 1935, was sent by J. Crawford from the Methodist-Episcopal Mission in Budaun, India, and is currently used to educate visitors: "About three years ago, I was indirectly responsible for the removal of a small piece of petrified wood from the National reserve forest. . . . You may smile at me and think me a bit foolish, but I have always been a law-abiding citizen and it has troubled me to have something in my possession that is not mine. So I am returning it to you . . . and hope it will reach you safely."

The east-west road through northern Arizona, originally called Old Trails Highway, was "two wagon tracks in the dirt," said Max Hunt, "and the occasional automobile that went by didn't have much of a highway to travel on." With rain or snow, and no graveled surface, a car could be hub deep in thick, sticky mud. (Cline Library NAU. PH.658.37, 1915.)

Around 1925, the road was improved with a berm. Dirt from the borrow ditch on either side was piled up and leveled off; then gravel was added. Even with gravel, the surface was slippery when wet, as seen in this September 9, 1933, accident 24 miles east of Holbrook. (Photograph by Norman Wallace; AHS/Tucson PC.180.F148/No. 2635.)

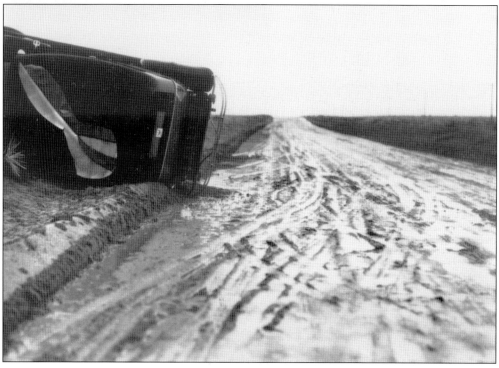

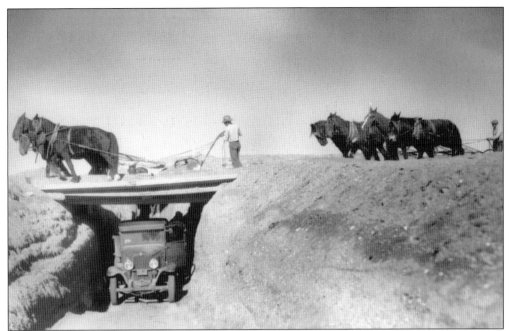

Paving Highway 66 in Arizona began in the mid-1930s. Horse (and mule) teams with Fresno scrapers improved the roadbed. Long tongues on the scrapers controlled the cutting edge, and horizontal buckets were filled with dirt. Here dirt is loaded into a truck 42 miles east of Holbrook on December 2, 1933. (Photograph by Norman Wallace; AHS/Tucson PC.180.F144/No. 2014.)

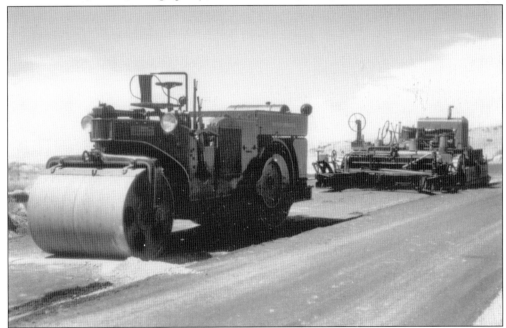

By August 7, 1936, the highway through the Petrified Forest was being paved. A Jaeger Paving Machine and a Buffalo Springfield Roller were used to finish the asphalt. In 1938, when the last piece of Arizona pavement was complete, a person could travel from Chicago to Los Angeles without driving on dirt. (Photograph by Norman Wallace; AHS/Tucson PC.180.F145/No. 1992.)

Route 66 became a conduit for migration. All automobile services were available in Holbrook, and residents profited from the business, including Chet Leavitt. The interior of his garage in 1928 (above) shows a full range of tires and inner tubes. His gas station (below, photographed in 1938) not only sold gasoline but also water. Holbrook's famous bad-tasting water was sold "by the gallon to tourists, who drank it, even if they had to hold their noses," reported the *Arizona Republic* in 1952. Leavitt profited from the notion of the times that mineral water had medicinal benefits. (Above NCHS; below photograph by Max Hunt.)

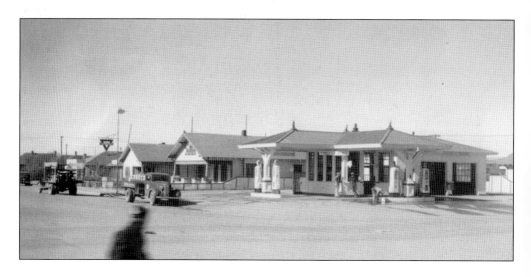

Holbrook residents (Harry Monson, above, in 1937) provided automobile service for travelers and residents alike, but Route 66 also became known as "Camino de la Muerte" or "Bloody 66" from numerous head-on collisions and deaths. In 1956, one of every six traffic deaths in Arizona occurred on 66. Clifton Lewis, whose father built the Wigwam Motel, said, "Dad had a wrecker way back in the early days. He used to sleep in the garage. The first one out was the one who got the business with the wreckers." This wreck (below) is the Joseph City school bus in 1938. Interstate 40 prevents many head-on collisions today. (Both photographs by Max Hunt.)

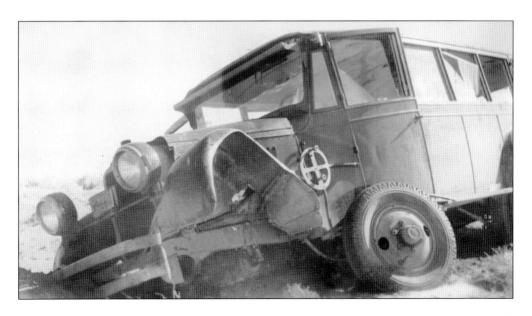

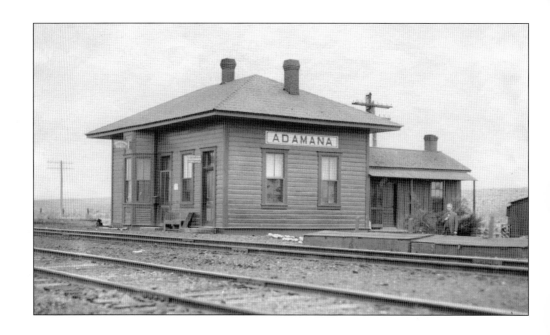

Locals tried to develop the area around Adamana. Ben Hunt, with his Mormon background of at least partial success using irrigation on marginal lands, tried to homestead. In March 1911, he wrote, "I am now at Adamana. Came up yesterday. Am putting in garden." However, he found it "not suitable" and relinquished his claim. The only successful developments at Adamana were accommodations for tourists, who debarked from the train at the small railway depot by the edge of the tracks (above). In 1912, visitors could take a six-hour tour of the nearby national monument traveling in a 12-passenger wagon pulled by four horses (below). They were promised a wide horizon and blue skies—and were probably seldom disappointed.

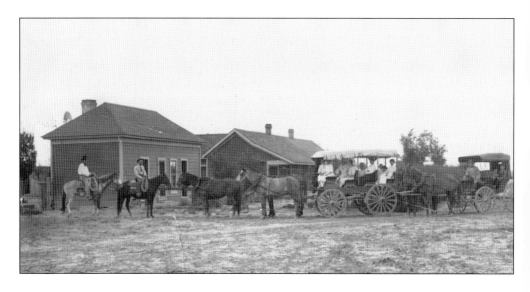

Easterners could see large pieces of petrified wood in the nation's capital as early as 1880. Hopefully, after seeing the fossilized logs in D.C., they would then want to see them in situ. The Santa Fe railroad added the *California Limited*, a first-class express between Chicago and Los Angeles. This c. 1904 advertisement promised landscapes "wholly unlike the East" and implied the availability of a 63-mile spur from Williams to the Grand Canyon and accommodations at Fred Harvey's El Tovar hotel. The photograph below (man unidentified) was used by the Atchison, Topeka, and Santa Fe Railway to promote tourism. (NCHS; AHF KR-153.)

Early Spanish explorers crossing the Painted Desert apparently missed seeing petrified wood. The first to note it was Capt. Lorenzo Sitgreaves, leading an 1851 U.S. Army expedition. In 1853, another expedition, led by Lt. Amiel Whipple, was scouting for a railway route from "the Mississippi River to the Pacific Ocean." Upon discovering a large deposit of petrified wood east of Holbrook, he named a nearby arroyo Lithodendron (literally, stone tree) Wash. The railroad brought visitors as early as the 1890s, including this unidentified couple in 1899. (PEFO No. 20843.)

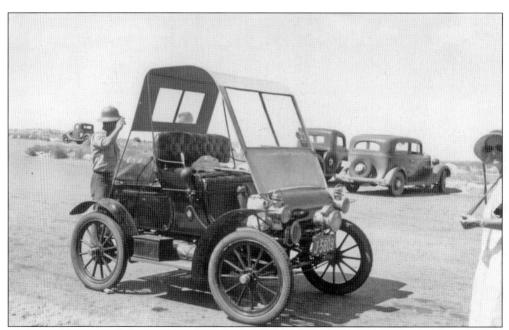

Highway 66 increased visitation to the Petrified Forest from 42,781 in 1924 to 245,640 in 1941. However, tourism in the later war years was greatly reduced. This unique touring car was used in the late 1930s. (Scott Benson.)

Locals and world-renowned naturalists became concerned about petrified wood lost from tourists and commercial operations. In 1888, fifteen tons of petrified wood were shipped from Holbrook. Especially troublesome were the Jasperized Wood Company, a lapidary business, and Armstrong Abrasives of Chicago, which wanted to crush the rocks for grindstones and emery wheels. Fortunately the Antiquities Act of 1906 meant the Petrified Forest could be designated a National Monument. Local resident Al Stevenson, photographed here, was appointed caretaker in 1907 but without salary. (PEFO No. 20844.)

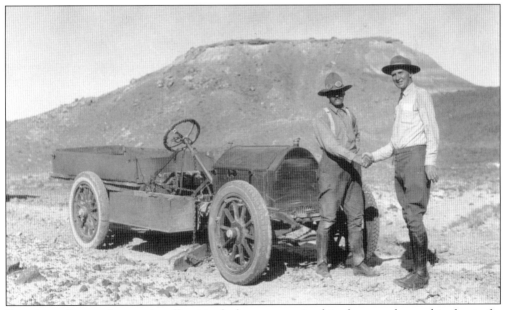

Superintendents only occasionally visited; the two men in this photograph stand in front of a flatbed vehicle used on one such visit in 1927. Presumably the chain and log underneath the vehicle was used to clear a road. (PEFO No. 26296.)

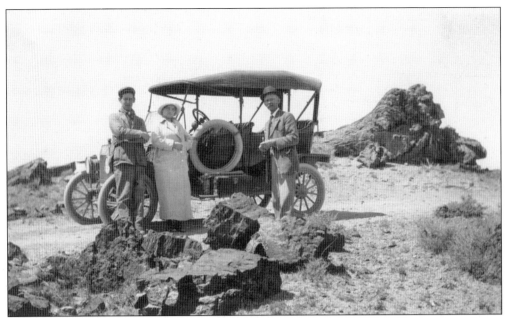

Tourists, both prominent and obscure, have traveled to the Petrified Forest for more than a century. Among the local visitors were Bill Woods and family. Woods was a telegraph operator and later worked for the telephone company.

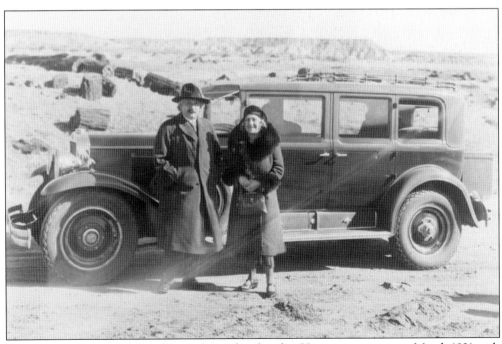

One famous visitor was Albert Einstein, standing beside a Harvey touring car in March 1931 with his wife, Elsa. In June 1930, Fred Harvey began using tan-and-brown seven-seat Packard cars to show tourists the sights. (PEFO No. 20826.)

Dorothy Meadows, mother of Garnette Franklin, visited the Painted Desert shortly after moving to Holbrook. The Meadows family arrived by train in 1919. Jim Meadows, a barber, was always ready to move. When he heard the train whistle, he longed for a cigarette and a ticket to nowhere in particular. (Gail Taylor.)

Dick Grigsby came to Arizona as a Hashknife cowboy. In 1929, he operated the single tourist facility, later known as Rainbow Forest Lodge, at the Petrified Forest National Monument. He was known for his propensity to drink when in Holbrook, and according to Jo Baeza, "The whiskey finally killed him when he was ninety-seven." (AHF VRN 261.)

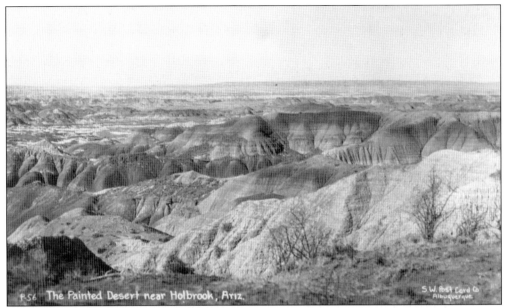

This undated postcard shows the Painted Desert area north of the Rio Puerco, which was an important acquisition in 1932. Land trades between the federal government and private landowners, the railroad, and the state more than doubled the size of the park. The colorful badlands created by wind and water erosion of bentonite clay had limited value for grazing, so all benefited from this trade.

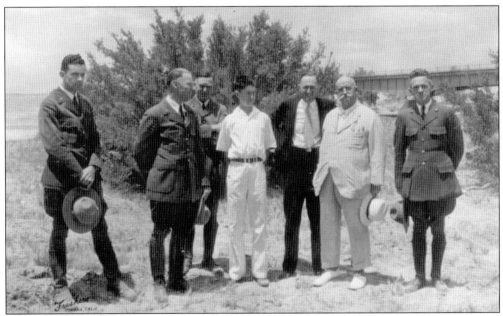

In his final term as governor, George W. P. Hunt (second from right), then in his 70s, came to the Petrified Forest on July 3–4, 1932, for the dedication of the Rio Puerco Bridge and Stephen T. Mather plaque. The Rio Puerco, prone to both flooding and quicksand, often prevented visitors from seeing the most impressive parts of the park. (Frasher Photos; PEFO No. 18358.)

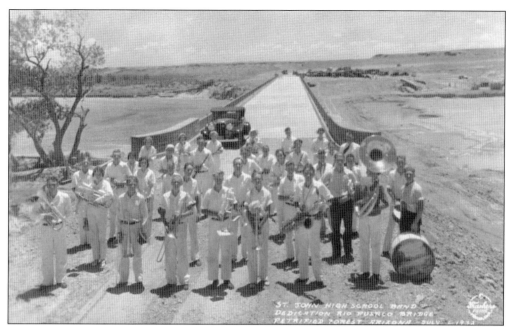

Citizens of Holbrook, Adamana, and St. Johns were always hoping for jobs at the Petrified Forest to add to the local economy. Besides a bridge over the Rio Puerco, they lobbied hard for National Park status and a road through the park connecting Highways 66 and 70 (the road from Holbrook to St. Johns). The dedication of the Rio Puerco Bridge and appropriation of money for the connecting road was celebrated by all. The St. Johns High School band came to play for the festivities, and the Holbrook Chamber of Commerce served a barbecue lunch to attending dignitaries. (Frasher Photos; PEFO No. 24301 and No. 24306.)

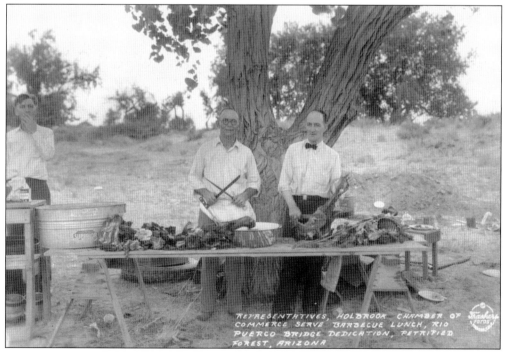

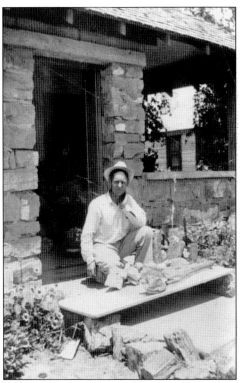

In the 1920s, scientists from the University of California began looking at Triassic fossils near Holbrook. Annie Alexander and Louise Kellogg came first, and then Dr. Charles L. Camp arrived. Locals Dick Grigsby and Pratt Greer (left with a phytosaur skull found in 1931) also hunted fossils. Two of Greer's skeletons are on display at the Mesa Southwest Museum, and a small reptile, *Anisodontosaurus greeri*, was named for him. (Ron Nichols.)

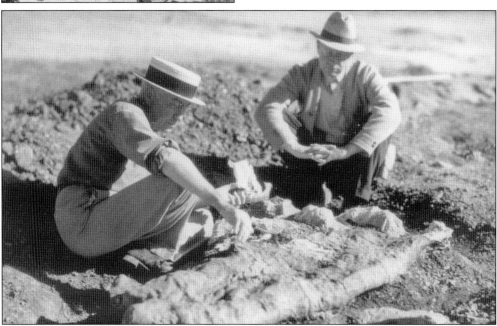

Another paleontologist to visit was Dr. Barnum Brown from the American Museum of Natural History. Brown first excavated in 1901, but he is shown (left) on September 13, 1936, when he unearthed a phytosaur skull measuring 4 feet, 8 inches. R. T. Bird may be the man on the right, and although labeled Painted Desert, this site may be near Cameron. (Photograph by Norman Wallace; AHS/Tucson PC.180.F11 No. 0145.)

In 1939, Dr. Camp (above) and Samuel Welles found an important fossil deposit about six miles west of Holbrook. Pearl Hunt wrote, "We have some neighbors, camped up in the pasture by the big hill, [a paleontologist] from Calif. and his helper. They are looking for bones and fossils of animals that lived millions & millions of years ago." Camp and Welles named this site the Holbrook Quarry (below) and excavated again in 1940 using dynamite to remove the cap rock. The University of California has 148 specimens from this site and another 56 from other sites immediately around Holbrook. (Both photographs by S. P. Welles; University of California Museum of Paleontology.)

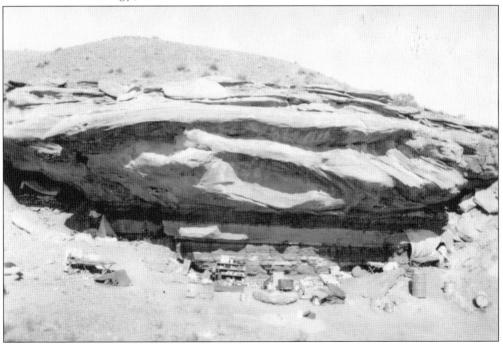

Tourists have always wanted petrified wood. Petrification occurs when minerals replace organic matter; the wood lying in silicon-rich water becomes a form of quartz. Colors are produced from the iron, carbon, cobalt, chromium, or manganese in the water. In 1936, Frank and Edna Dobell returned to Holbrook and began working at the Rainbow Forest Lodge. (Photograph by Paul M. Steel; PEFO No. 15741.)

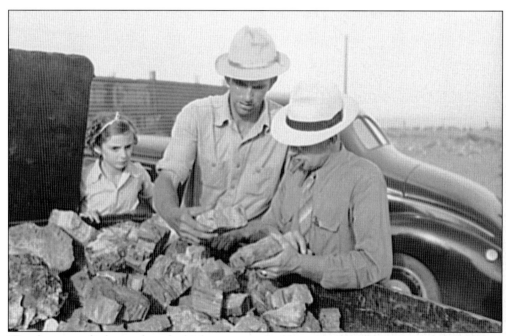

"Frank put up a little stand on the highway . . . and sold petrified wood for five cents," said Edna. "It wasn't a great business—in fact, we almost starved. But it got better. It got a lot better." In August 1939, Russell Lee photographed these tourists purchasing the colorful rocks, probably at the north end of the park. (Library of Congress.)

The Civilian Conservation Corps (CCC), nicknamed "Roosevelt's Tree Army," was one of Franklin D. Roosevelt's first relief projects in the 1930s. It was undoubtedly FDR's most popular relief program. Although many of the jobs went to people from other states, local men who understood conservation issues as well as anyone in that era filled nearly all supervisory jobs. Two Holbrook men who worked for the CCC were Scott Benson (right) and Denver Nichols (below right, with Benson). (Scott Benson.)

At the Petrified Forest, CCC men built roads and trails, helped with excavations, and planted cottonwood slips. Their most important contribution was the renovation of the Painted Desert Inn. Renovation began in May 1937 and took nearly three years. CCC enrollees are shown in front of the inn on March 5, 1938. (PEFO No. 26206.1.)

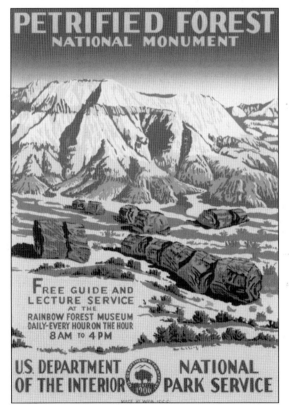

Another organization providing jobs was the WPA, whose Federal Art Project commissioned 35,000 posters to stimulate public interest in education, theater, health, safety, and travel across America. This c. 1939 poster by an unknown artist was created for the Petrified Forest National Monument. Reproduction posters and postcards are available today at most tourist sites. (PEFO.)

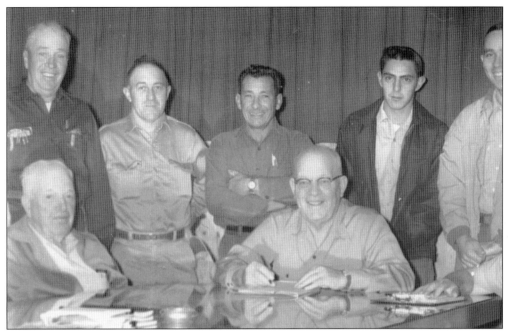

Billboards along Route 66 included the bright yellow signs with red letters advertising Whiting Brothers motels and gas stations. This photograph shows Ernest (seated, left) and Arthur Whiting (seated, right) with their employees. The signs were 300 feet long and 6 feet high. The Whiting brothers were also in the lumber business and thought that these colors would catch the eye of every tourist.

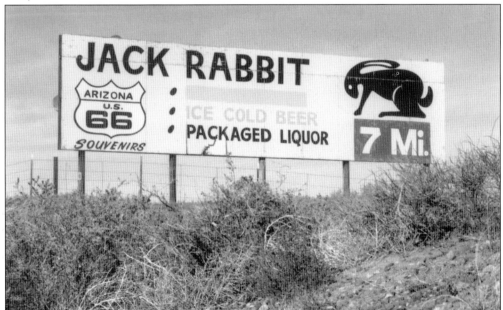

Other memorable signs included those for Wayne Troutner's Store for Men in Winslow and for the Jackrabbit Trading Post near Joseph City. In the 1940s, store owners Troutner and James Taylor put up signs all over the nation. A rabbit and a sexy cowgirl advertising the men's clothing store were even at the entrance of the Holland Tunnel in New York City. (Photograph by David Ellis.)

Local resident Helen Ferguson designed the jackrabbit. Despite battling the effects of polio, Helen, who was the daughter of Judge William E. Ferguson, worked at the courthouse. She also had received commercial art training in Phoenix. Her jackrabbit (especially the ears) may have been influenced by Mimbres pottery. (William E. Ferguson.)

In 1946, Mamie Asken of Muleshoe, Texas, received this postcard, with the following message: "Eating breakfast here. Annie." Large-letter linen postcards, produced by Curt Otto Teich from 1933 to 1958, became world famous. Each letter contained a representative image; Holbrook's include, from left to right, the drugstore, petrified wood, Navajo Indians, a Native American on a horse, unidentified, the Masonic lodge, the high school, and Eagle Rock. With grass in front, no one believes the R really represents Holbrook.

Six
Yesterday and Today

In 1939, many in Navajo County remembered the Great War and had no desire to participate in another European conflict. Editorials with such headlines as "Neutrality and Peace" stated, "All of Europe is not worth the blood of a single American boy." However, the editor eventually wrote, "There seems only the road of prayer and preparation."

With the attack on Pearl Harbor, all thoughts of isolationism vanished. Holbrook's first response was to purchase $10,000 in war bonds. Ben Hunt explained that "no 'high pressure' tactics are to be used to boost sale of the bonds and stamps," but everyone bought what they could. Children filled stamp books, 25¢ at a time. Even stores advocated buying war bonds; Babbitts advertised, "the Easter Parade won't be complete without a new 'Nelly Don' dress or a two-piece suit. Nor without 'An Easter War Bond.' " Holbrook supported its servicemen with letters, bonds, and rationing.

One supporter was "San Diego" Rawson, proprietor of the Old Frontier souvenir shop. The *Holbrook Tribune-News* described Rawson as "one of the most colorful, 'wild and wooly' old-timers in Arizona." He offered his horse to the Red Cross for auction or raffle saying, "money is almost unknown at my place. But I have a fine pinto horse, four years old . . . [that] would bring at private sale $100. . . . I am not active enough to take a part in this war but I want to do my bit. I have no money, even for stamps. I suppose you know roadside curio places are about off the map."

Change came to Holbrook after World War II. The center of town moved both north (motels, homes, and restaurants) and south (new Navajo County buildings). Holbrook celebrated two birthdays, its 50th year of incorporation in 1967 and, more importantly, its 100th birthday in 1981. In an editorial titled "Happy Birthday, Holbrook!" Ron Grimsley described Holbrook citizens, saying, "You'll find most of them call Holbrook hot, cold, dusty, windy, stormy, dry and barren. They also call it home."

Holbrook today is also home to the Petrified Forest.

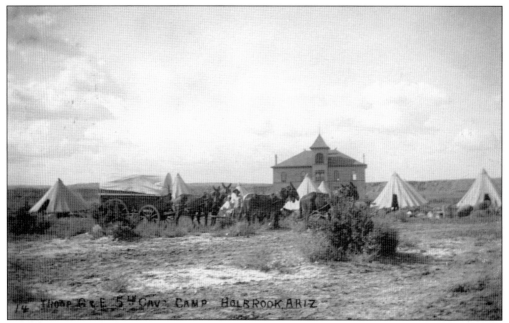

Dates for this encampment vary from 1910 to 1918. If it dates to about 1910, these photographs may be associated with Hopi resistance to children attending school. Troops went to Hopi villages in 1906 when uncooperative Hopis, termed "Hostiles," hid their children. Cooperative Hopis were termed "Friendlies." Many Hostile men were imprisoned; all children were sent to boarding school. Although Friendly children returned home each summer, Hostile children were not permitted home for four years. Helen Sekaquaptewa wrote that in June 1910, the fathers "came, riding burros, asking permission to take their children home for two weeks to be there at the Home Dance." Permission was given, but the children did not return to school. A year later, "the children from Hotevilla were gathered up by soldiers and again loaded into wagons and taken back to school" and kept year-round. (Arizona Collection, ASU Libraries, CP.SPC.177.160.103 and 177.160.113.)

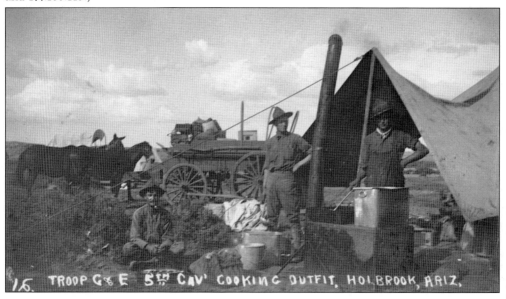

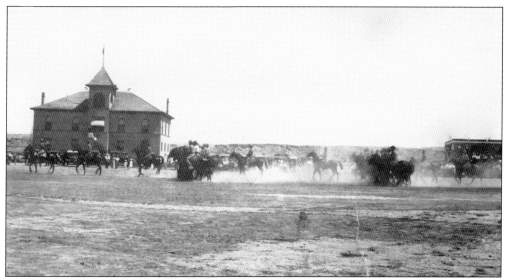

This photograph was taken at the same time as the two on the page 104. If these three cavalry photographs are from 1918, then they represent World War I era. In 1940, Fred Schuster, who served in France during World War I, spoke to the Rotary Club supporting a selective service draft. He reminded members that it took 12 months to get men into the field then.

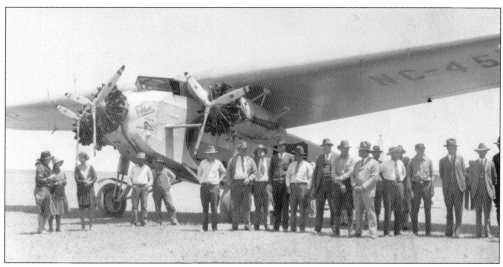

In 1929, air service was scheduled for Holbrook and the first airplane landed. Many came to see the airplane, a Fokker F-10-A Super-Trimotor (sometimes mislabeled Ford, but identified by registration number on wing and name on nose). One year later, Holbrook lost this service to Winslow, but this may have encouraged Dr. J. Minor Park (physician and mayor) to advocate air-cadet training during World War II.

In October 1941, the army placed an advertisement for horses to be used in the cavalry. They had to be four to eight years old, broken, dourine free, and a solid color—no grays, palominos, or paints. The army was willing to pay $135–$200 per horse. The advertisement resulted in two railroad carloads shipped from Holbrook. (Photograph by Max Hunt, 1938.)

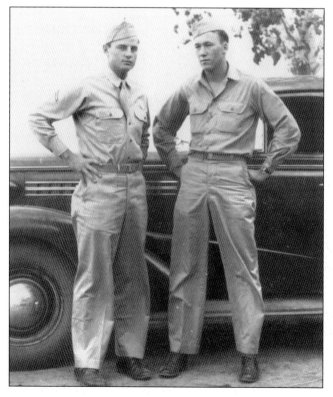

After Pearl Harbor, Bruce Hunt (right, with Jay Miller) was at Campbell's Coffee House. Dick Mester told "us we would all be in it before it was over," wrote Hunt. "I thought he was wrong. . . . How naive we were." Nearly four years later, Hunt, a serviceman in India, was watching a snake charmer. Among the spectators was Lee Kutch, one of the Coffee House friends. (Photograph by Max Hunt.)

Many men came to Holbrook for employment, including Arthur Palmer from Taylor, who was county assessor from 1936 to 1962. Palmer's wife, Eva, organized many charitable events. As part of the third war-bond drive, she organized a "Bond Blitz Dance." She went from house to house soliciting money for tickets. The Calling All Girls Club raised $130 in stamps from corsages. (Both Renee Hughes.)

In 1943, children in the Catholic catechism class said, "*Santo Nino va a la querra* [sic]"—Santa Claus has gone to war. They usually received their only toys at the Christmas party, but when asked if money for the party could buy a war bond (later used for construction of a new church), every hand shot up. The new Our Lady of Guadalupe Catholic Church was completed in 1968.

Holbrook citizens built an airport and contracted to train naval air cadets. By April 23, 1943, they had 60 cadets, 14 Piper Cubs, 3 Taylorcrafts, 3 Aroncas, 1 Culver Dart, 15 instructors, 8 mechanics, and 6 office workers. Buildings south of the railroad tracks were converted into a kitchen/dining area. "Our teacher, LeRoy Gibbons [above]," wrote Zena Hunt, "fed those boys three times a day. . . . Next to the dining hall was the 'ward room' with lounge chairs and pool tables for the boys to relax with their dates. The rest of the block was used for office space . . . and the old Hotel across the street [below] was fixed up for barracks." The first group of 38 graduated in July 1943 as Company H, Holbrook War Training Battalion. (Photograph by William E. Ferguson; NCHS.)

Cadets attended the 24th of July dance in Snowflake, toured the Petrified Forest, and swam at the Woodruff dam (above). "Let's make it a 'cadet in every home' Christmas day in Holbrook," the newspaper suggested. "The Navy Cadets were a really special fun part of my high school days," wrote Zena Hunt. "Poor local boys didn't have a date for two years. They are still bitter about it." The last class began training on May 11, 1944, and graduated in August. Four hundred eighty-three men received elementary training and 362 men received intermediate, although some men participated in both trainings. About 500 men trained in Holbrook, and an estimated $360,000 was added to the local economy. (Zena Hunt.)

SPECIAL INVITATION
~~Cadet-Sponsored,~~ M.I.A. Supervised
DANCE
Crazy antics (Yow) (And How) Including Prancing, Dancing, Old and New Entertainment (Oh Baby) For U And Food and Refreshments Galore.

Date, Saturday, April Fool, 1944. Place, L.D.S. Church Amusement Hall

Time, 2000-2400 Abnormal Cadet Time Or Naval Observatory Time;

8:00 p. m. to 12 p. m. Roosevelt? Osborn? Hancock? M. S. War Time? House Bill No. 1313—Senate Bill No. 7-11. Legal Time Change April 1. Signed by Osborn. Why???

Admission—One Grand Sense of Humor

Let's Don't Let The Navy Sink!

Merwyn Porter wrote to servicemen (Scott Benson here at Fort Hood, Texas): "January 1, we got out of the state of Arizona and entered the state of Uncertainty . . . we changed from War time to Standard time. As you know, we have operated since early 1942 an hour ahead of standard time. Finally, the Governor changed back to Standard time; after ten days, the City Council decided that Holbrook would go back to War time, but the County Attorney decided that the courthouse would operate on [Standard] time. . . . As I told one group of people: 'God made the time in the first place; then FDR overruled him. Governor Osborne overruled FDR, then the City Council overruled Governor Osborne; and Dod[d] Greer overruled the City Council.' " The *Tribune-News* noted, " 'Passing the time of day' is no longer a pleasantry but a good way to start an argument." (Above Scott Benson; below Zena Hunt.)

War rationing was most severe for restaurant owners (Scorse's Green Lantern, above). Dick Mester, proprietor of Campbell's Coffee House, remembered difficulties procuring meat. "Meat points and help problems nearly killed me," he said. "Everything the general public was rationed on, we were too. We could get only 50 percent of anything we had before the war." Eventually he was closing his restaurant one to several days a week and two to three months at a time. Often he simply did not have chicken, but milk and beef were available locally. After the war, Mester catered to bus travelers and opened the Automat (below).

The enlistment of Apache, Navajo, and Hopi Indians was a point of some local pride. Philip Johnston, who moved to the Navajo reservation when he was four, believed that the Navajo language could be used as an unbreakable code. After persuading the marines to try it, many Navajo men were used as Code Talkers. In October 1942, Johnston came on a recruiting tour (above), and the *Holbrook Tribune-News* published an official U.S. Marine Corps base photograph in March 1943 (below) of an all-Navajo platoon studying "to be good Marines." On September 29, 1944, the newspaper reported that the "signal corps, [is] using tribal language, which is more perplexing than code, to bamboozle the enemy." (Above Cline Library, NAU.PH.413.1299; below NCHS.)

Brothers serving together was not always good, but Belton (left) and Duffy Palmer fought to stay together (here in Alaska). Duffy was shot in the neck at Iwo Jima and only survived because Belton administered first aid. "I pray God will bless that brother of mine," Duffy wrote, "and in time I hope I can in some way show him how much I appreciate him and love him for saving my life." (Renee Hughes.)

The Kill Kare Klub sent Christmas packages in 1942. Cpl. Delmar Ferguson wrote, "I was very pleasantly surprised at receiving your nice Christmas gift. Was especially pleased with the pinions as it has been quite awhile since I have eaten any. . . . It takes people like you in Holbrook to make us fellows know that we have a home and place to come back to when this is all over." (William E. Ferguson.)

Scott Benson (above) was standing amid the ruins of Bayreuth, Germany, when peace was declared in Europe. The newspaper reported "appropriately solemn" observances on V-E and V-J Days. Pearl Hunt wrote: "Yes we are all truly thankful that the war is over. War is a horrible game for the victor as well as the vanquished. . . . All the worries for me will not be over until all you boys are out of the Service and established in some peaceful pursuits." Bill and Betty (Lopp) Ferguson remember that Route 66 closed for a street dance and many marriages after the war—including their own on August 16, 1946. This photograph of Judge William E. and Lula Ferguson (the parents of the groom) was taken at the wedding. (Above Scott Benson; below William E. Ferguson.)

In 1944, Charles Turley, age 19, of Woodruff, was killed in Italy. Posthumously awarded a Purple Heart, he was also honored in a uniquely Navajo County way. A beautiful Navajo rug, 24 inches by 30 inches, in the form of a service flag (with red, white, and blue border and a gold star), was woven by Helena Begay and presented to his parents. His brother, Frank, displays the weaving in 2006. (Photograph by James Hunt.)

The American Legion erected this monument to honor the dead from World War I, World War II, and the Korean War. Dedicated in 1953, names of men from Navajo County are inscribed for each war (10, 106, and 16, respectively). Here, at the dedication are, from left to right, Joe Gerwitz, Scott Benson, Don Udall, William Bourdon, Ben Hunt, W. J. Crozer, William Bourdon Jr., J. M. Wicker, and Hyrum Hendrickson. (Bruce Hunt.)

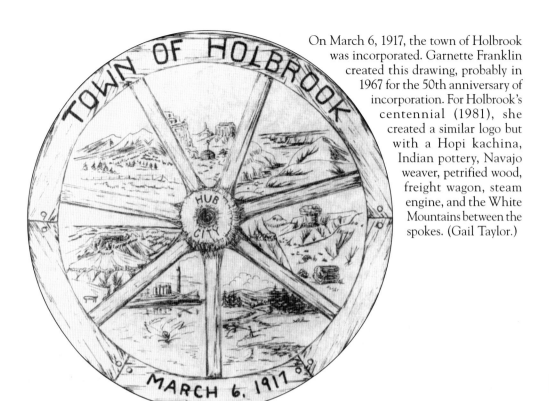

On March 6, 1917, the town of Holbrook was incorporated. Garnette Franklin created this drawing, probably in 1967 for the 50th anniversary of incorporation. For Holbrook's centennial (1981), she created a similar logo but with a Hopi kachina, Indian pottery, Navajo weaver, petrified wood, freight wagon, steam engine, and the White Mountains between the spokes. (Gail Taylor.)

In 1986, Charles Lisitzky was honored for 20 years of service to the Petrified Forest National Park through the museum association. A World War I veteran and longtime A&B Schuster employee, Lisitzky was involved in many civic organizations. Today Paul DoBell is executive director of the museum association and serves on many of the same nonprofit boards. His name, Paul Sell DoBell II, honors early Petrified Forest entrepreneur J. C. Paulsell.

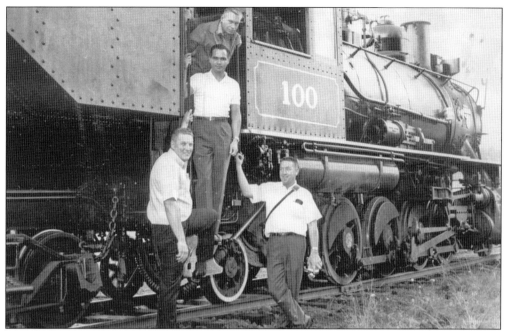

Representing Holbrook's long railroading tradition, No. 100 (above), a small switch engine, may be on the Apache Railway; the only person identified is Bob Mann (right). Steam engine No. 5751 (below) made a historic run through northern Arizona in 1993. In 1996, Burlington Northern purchased the Atchison, Topeka, and Santa Fe, renaming it the Burlington Northern Santa Fe Railway (BNSF). BNSF is known for its colorful engines. Although they still use some Santa Fe red-and-silver "war bonnet" engines, eventually all will be orange with a dark green stripe (sometimes called "pumpkins"). BNSF has recently restored the Holbrook depot. (Above NCHS; below photograph by William E. Ferguson.)

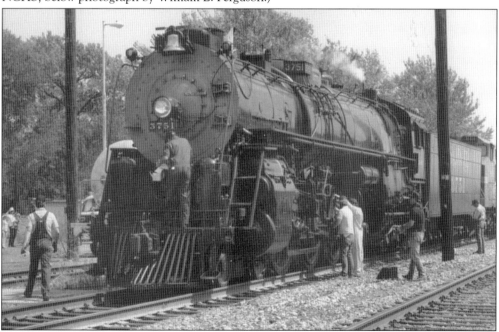

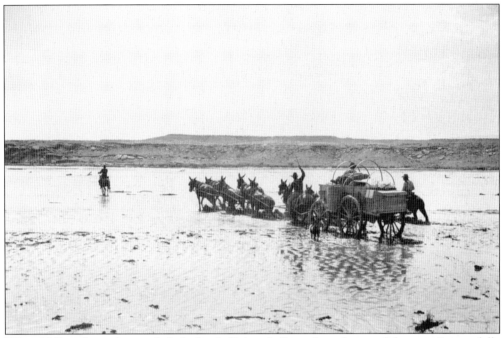

When Holbrook was first settled, the Little Colorado River flowed most of the year. Successfully crossing it involved finding a rocky bottom. Frederick Monsen photographed these "pioneers crossing the little Colorado" in 1885 (above), six mules pulling an uncovered wagon. Monsen's photographs burned in a fire after the 1906 San Francisco earthquake, but he located existing prints and made new negatives. A modern crossing of the Little Colorado River, whether at flood stage or dry, was made simple by the construction of an adequate bridge (below). (Above Huntington Library, San Marino, California; below photograph by Garnette Franklin, NCHS.)

Labeled "Two hot boys of Arizona," Lloyd Henning identified these men as H. A. Pease (left), publisher, and Deafy Moore, printer, of the *Argus* in 1901. A. F. Banta established the *Holbrook Argus* in 1895 and published political and local news for 18 years. He served as printer, typesetter, editor, publisher and/or founder of newspapers in Albuquerque, Prescott, Yuma, Tucson, and St. Johns.

In 1969, Paul Barger purchased newspapers serving Holbrook, Snowflake, and Winslow. In 1999, Barger said his goal was "to produce the most accurate, most complete newspaper humanly possible." But he also added, "We want to have a little fun doing it. Sure, we need to be serious in the handling of our news and advertising. . . . And yet, I would hate to go through life doing something I did not enjoy."

Holbrook Boy Scouts Val (above, left) and Van Palmer, ages 15 and 13 in 1944, are ready for a week of summer camp in the White Mountains. A Girl Scout troop (below, possibly from the 1950s) is learning the same patriotism and community-service skills. More recently, in October 2006, Elizabeth Perry, Hope Serna, Macie Williams, Amber Williams, Eleanor Henderson, and Jennifer Ortega from Girl Scout Troop No. 2601 painted bleachers at the Lisitzky Park ball field, a requirement for their Bronze Award. JoLynn Fox photographed the girls, "wearing some of the paint themselves," for the newspaper. (Above Renee Hughes; below NCHS.)

Gwen Headley included Holbrook's Wigwam Motel in her book *Architectural Follies in America* (1996). Fortunately for Holbrook's reputation, an architectural folly means something whimsical rather than something foolish. Architect Frank Radford planned for tepees to be built across the United States and provided blueprints free. Only three motels exist today; Holbrook's is listed on the National Register of Historic Places as "Wigwam Motel No. 6." Chester Lewis (above right with Charles Hardy in the 1930s) built the tepees after seeing some in Kentucky. He began in 1946 and finished in 1950, doing most of the work himself. Many a Navajo County child secretly wished to spend the night, and not a few have indulged as adults (below). (Above Renee Hughes; below photograph by James Hunt.)

121

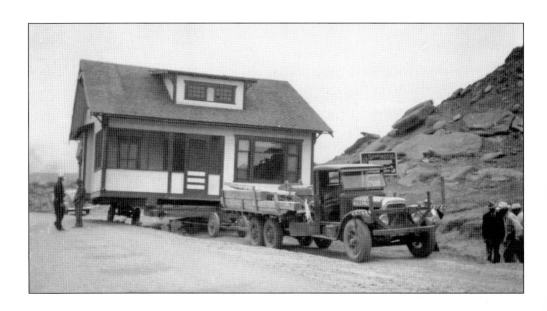

Holbrook has a long history of moving houses, including the Bill Cross home (above, no date). A later house mover, Cal Barker, came to Holbrook in 1948 and began moving houses in the 1960s, including the old hospital; Mary Barker is currently documenting these moves. A different move (below) was photographed in 1999 when Jim Gray's Petrified Wood Company was relocated to the junction of Highways 77 and 180. A crane is used to move the large petrified wood stump; a pile of geodes is in the left hand corner of the photograph. (Above NCHS; below photograph by Garnette Franklin, NCHS.)

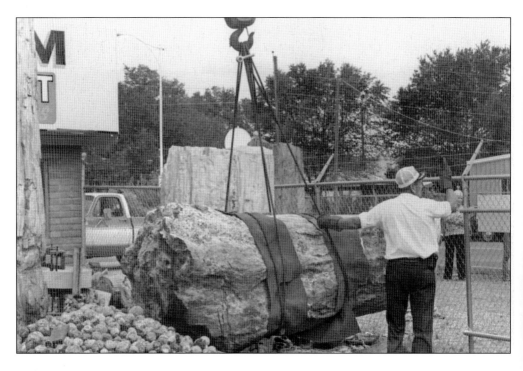

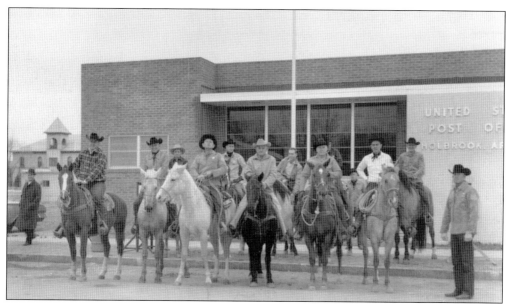

Today the name Hashknife has two meanings. Originally referring to early cowboys working for the Aztec Land and Cattle Company, the name now also refers to search and rescue and a Pony Express ride from Holbrook to Scottsdale. In 1955, Navajo County sheriff Ben Pearson and his friend Roy Downing organized a search-and-rescue group in response to hunters stranded by snow in 1954. A Pony Express ride was added in 1959. The ride begins with the swearing in of posse members by Holbrook's postmaster (above in front of the post office). The first ride was nonstop, but now camp is made near Payson and on the Verde River. Cooks for the ride during the 1960s (below, from left to right) were C. F. Lee, Victor Gerwitz, and "Slim" Turner.

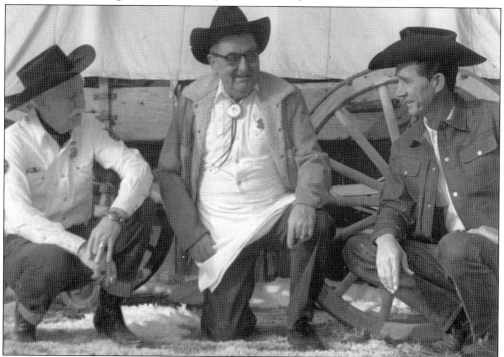

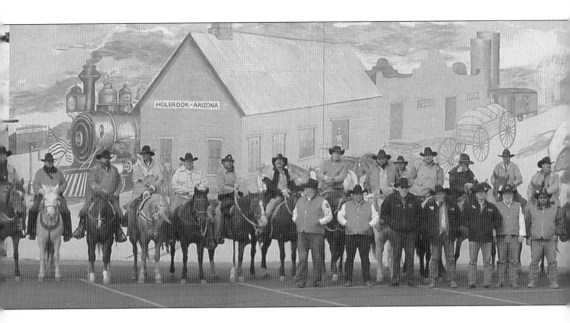

The mural *Heart of the Old West* was painted by Liz Nichols for "all who love Holbrook" (from September 11, 2001, to January 18, 2002). Nichols (below) began drawing at age three. Each aspect of the mural tells of Holbrook. James and Hannah Stott (in front of the depot) arrive to settle the affairs of their son Jamie (lynched in 1888). The Bushman family (by the ACMI) comes from Dry Lake for supplies, and Sheriffs Owens and Wattron bring law and justice to Holbrook.

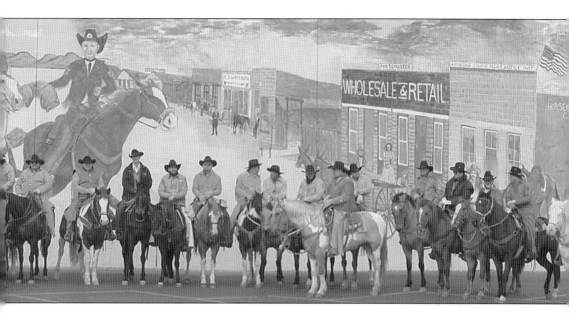

In the center are Sheriff Ben Pearson and Roy Downing as Hashknife Posse Pony Express Riders. Below is an early commemorative stamp designed by Garnette Franklin. A ride from Holbrook to Scottsdale each January carries the mail and provides a special cancelation. (Above Matthew Barger; below left JoLynn Fox; below right Gail Taylor.)

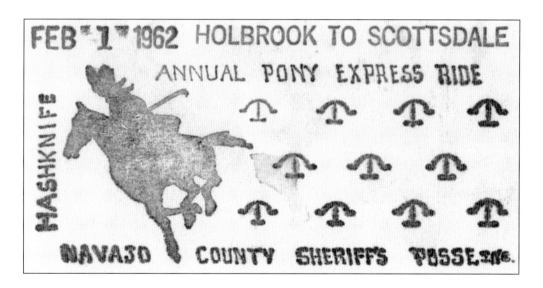

The Petrified Forest, Painted Desert, and Grand Canyon make Arizona premier tourist country. In 1878, Gen. William Tecumseh Sherman arranged for the shipment of two large logs of petrified wood to Washington, D.C.; they were on display for many years but are now in storage. Outside the National Museum of Natural History today (between the U.S. Capitol and the Washington Monument) are two other pieces donated to the Smithsonian in 1980. As noted on the plaque, they were contributed by "Mr. and Mrs. James M. Gray, Mr. and Mrs. Herbert Zuhl, [and the] City of Holbrook." The ends of each piece have been polished, a difficult task only possible in experienced rock shops such as Holbrook's. Many children and adults, U.S. citizens and foreign nationals, take home photographs of this gift to the nation. (Both photographs by Merlin Ellis.)

ADDITIONAL READING

Baeza, Jo. "The Lynching of Stott, Scott, and Wilson." *Arizona Highways* 75 (10): 34–37, 1999.

Barger, Matthew. *Holbrook, Arizona Guide*. Holbrook, AZ: Chamber of Commerce, c. 2000.

Berg, Erik. " 'Big Boom Predicted:' Oil Exploration and Speculation in Northern Arizona, 1900–1930." *Journal of Arizona History* 41: 1–30, 2000.

Berkman, Pamela, ed. *The History of the Atchison, Topeka and Santa Fe*. Greenwich, CT: Bonanza Books, 1988.

Carlock, Robert H. *The Hashknife: The Early Days of the Aztec Land and Cattle Company, Limited*. Tucson, AZ: Westernlore Press, 1994.

Dedera, Don. *A Little War of Our Own: The Pleasant Valley Feud Revisited*. Flagstaff, AZ: Northland Press, 1988.

Hanchett, Leland J. Jr. *The Crooked Trail to Holbrook*. Phoenix, AZ: Arrowhead Press, 1993.

Jennings, James R. *Arizona was the West*. San Antonio, TX: Naylor Company, 1970.

Johnston, Lyle, ed. *Centennial Memories*. Holbrook, AZ: Friends of the Holbrook Public Library, 1993.

Kartchner, Kenner Casteel, with Larry V. Shumway, ed. *Frontier Fiddler: The Life of a Northern Arizona Pioneer*. Tucson, AZ: University of Arizona Press, 1990.

Lubick, George M. *Petrified Forest National Park: A Wilderness Bound in Time*. Tucson, AZ: University of Arizona Press, 1996.

Peterson, Charles S. *Take Up Your Mission: Mormon Colonizing Along the Little Colorado River, 1870–1900*. Tucson, AZ: University of Arizona Press, 1973.

Scott, Quinta, and Susan Croce Kelly. *Route 66: The Highway and Its People*. Norman, OK: University of Oklahoma Press, 1988.

Wayte, Harold C. Jr. *A History of Holbrook and the Little Colorado Country (1540–1962)*. Tucson, AZ: M.S. Thesis, University of Arizona, 1962.

Across America, People are Discovering Something Wonderful. Their Heritage.

Arcadia Publishing is the leading local history publisher in the United States. With more than 3,000 titles in print and hundreds of new titles released every year, Arcadia has extensive specialized experience chronicling the history of communities and celebrating America's hidden stories, bringing to life the people, places, and events from the past. To discover the history of other communities across the nation, please visit:

www.arcadiapublishing.com

Customized search tools allow you to find regional history books about the town where you grew up, the cities where your friends and family live, the town where your parents met, or even that retirement spot you've been dreaming about.